IMAGES
of America

TUCKER COUNTY

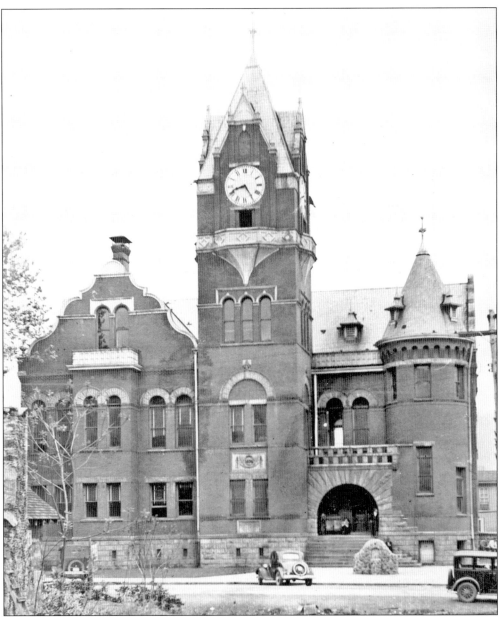

The Tucker County Courthouse is a massive red-brick structure with Romanesque Revival details. Flanking the entrance portal of rock-faced stone are two towers. The courthouse was designed by West Virginia architect Frank Milburn in 1898, and construction was completed in 1900. This photograph from the 1920s shows the newly installed clock in the central tower. After almost 20 years of lost time, the clock was put in place. Thanks to the National Prohibition Amendment of 1920, funding became available to pay for the clock's installation. Collection of fines from illegal bootlegging and stills provided the nearly $3,000 needed to purchase and install the clock in the tower. Next to the courthouse is the sheriff's residence and jail (not shown), a red-brick building with a corner porch. Construction of this building was completed in 1896, a few years before the courthouse, by the Wheeling firm of Franzheim, Geisey, and Faris.

Cynthia A. Phillips

Copyright © 2005 by Cynthia A. Phillips
ISBN 978-0-7385-1800-8

Published by Arcadia Publishing
Charleston SC, Chicago IL, Portsmouth NH, San Francisco CA

Printed in the United States of America

Library of Congress Catalog Card Number: 2005920920

For all general information contact Arcadia Publishing at:
Telephone 843-853-2070
Fax 843-853-0044
E-mail sales@arcadiapublishing.com
For customer service and orders:
Toll-Free 1-888-313-2665

Visit us on the Internet at www.arcadiapublishing.com

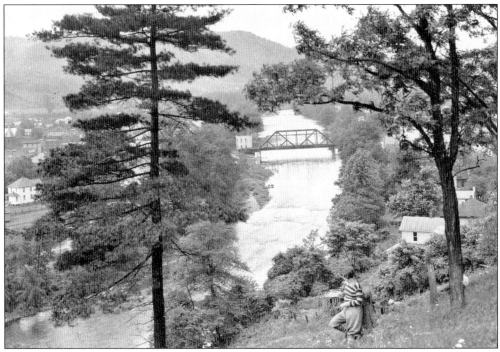

Shavers Fork flows placidly through Parsons in 1923. Shavers Fork originates in Pocahontas County and flows 84 miles across Pocahontas, Randolph, and Tucker Counties. Along its course are favorite fishing spots, deep swimming pools, and rushing white water. The river ends just downstream from Parsons where Shavers Fork joins the waters of the Black Fork River to form the Cheat River.

Contents

Acknowledgments		6
Introduction		8
1.	A Thin Silver Thread: Transportation	9
2.	Off the Mountain: Parsons	19
3.	Down by the Riverside: Hambleton and Hendricks	37
4.	On the Mountain: Thomas	47
5.	At the Forest's Edge: Davis	73
6.	Up in the Valley: Canaan Valley	89
7.	Wood Hicks and Knot Bumpers: Forty Years of Logging	101
8.	To Protect and Restore: Forest Recovery	115
9.	Bountiful Gifts: Natural Resources	123
Bibliography		128

ACKNOWLEDGMENTS

The seed of inspiration for this book took hold in 2000 when I had the opportunity to become involved in an oral history project in Tucker County. This work introduced me to the people of Tucker County and their history. If it were not for their vivid stories, generous contribution of information, and patient instruction, this book would not have been possible. This book is dedicated to the citizens of Tucker County.

Special thanks must go to those who contributed photographs from their private collections: Jane Barb, Russell Cooper, Wilburn Fansler, Ed Kepner, John Lutz, Virginia Parsons and her daughter Sharon Stavrakis, Walter Raese and his daughter Mary Jean Moroney, P. K. Salovaara, David and Wilda Strahin, Frances Tekavec and her daughter Veronica Staron, and Dorothy Thompson.

The valuable visual records of Tucker County that belong to the citizens of West Virginia helped to bring many stories to life. I would like to thank guardians and stewards of these public collections: archivist Debra Basham and the staff of West Virginia State Archives; John Calabrese and Valerie McCormack at the United States Forest Service in Elkins; the very able and generous Lori Hostuttler and Christine Venham at the West Virginia and Regional History Collection; Jim and Alice Phillips of Tucker County Historical Society; and Bob Shives of the Western Maryland Railway Historical Society.

Also making this project possible were Matt Quattro and the Thomas Education Center with a generous loan of computer equipment. When my energy was waning, members of the Friends of the 500th brought enthusiasm, interest, and encouragement. Thank you for including my quest for photographs in your own project. David Lesher provided information from his wealth of knowledge and interest in historical weather data from Canaan Valley.

A portion of the royalties from the sale of this book will be donated to a local program called Tucker County Connections. Tucker County Connections encourages fifth-grade students to learn about Tucker County, its abundant natural and cultural resources, and its rich human history and heritage. Through this program, students obtain an understanding of their own connection to Tucker County.

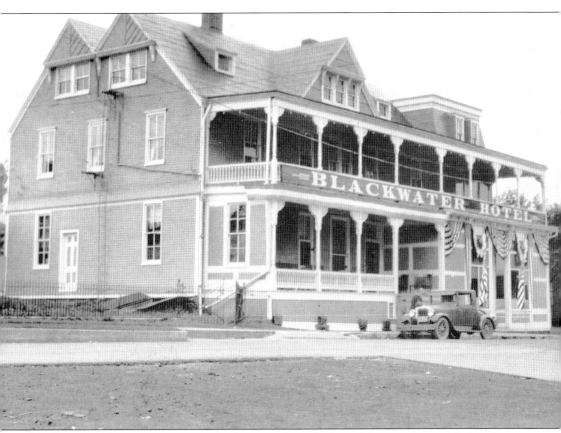

The Blackwater Hotel in Davis was built in 1886 by the West Virginia Central & Pittsburg Railway Company. For many years, it was the outstanding hotel along the line from Cumberland to Elkins and had a reputation for providing spectacular food and service. It boasted 40 rooms, a barbershop, and barroom. Located just up the hill and within sight of the train station in Davis, the Blackwater Hotel was a five-minute walk from many services offered in more populated areas. Lumber mills, restaurants, banks, mercantile operations, boarding houses, and even a miniature golf course thrived in the town. When the railroad discontinued service in 1942, the grand hotel was dismantled by the owners, Mr. and Mrs. William Kramer. (Courtesy Dorothy Thompson.)

INTRODUCTION

This book includes images of Tucker County from 1884 until around 1960. This period was an era of extraction and export of natural resources on a monumental scale. A parallel and compelling story of immigration, integration, and adaptation will also be told through these images.

Although founded on March 6, 1856, Tucker County remained a geographically isolated area of Virginia (later West Virginia) until the 1880s and the arrival of industrialist Henry Gassaway Davis's railroad, the West Virginia Central & Pittsburg. Areas around the river valleys in Tucker County were those first occupied by whites in the late 1700s. Cultivation of the fertile bottom land gave rise to relatively prosperous farming villages. One such village, Saint George, became the seat of Tucker County. Inaccessible mountaintops remained sparsely populated, and attempts to settle these areas turned back all but the hardiest of settlers.

The railroad greatly changed the social, physical, and political landscape of the county. Avenues for exportation of raw materials were opened up and provided a one-way ticket for a cheap labor force. A dramatic increase and diversification of the population occurred in the late 1800s in response to the availability of work. Experienced woodsmen from Michigan, Canada, New England, Pennsylvania, and Europe joined local workers to harvest and process lumber. Soon, others followed from eastern and central Europe, Russia, the Baltic countries, Italy, and the American South to take their places in mines and at the coke ovens. Some arrived to waiting families or former neighbors. Others stayed and worked only long enough to earn their passage back home. Single men came and died performing dangerous and menial jobs, with only a gravestone purchased by their countrymen to mark their passing. In a strange, new place, they found community through familiar rituals, shared food, and commemorations.

As time and distance separated them from their native countries, the inevitable happened. Most assimilated and adapted, making the difficult transition by shaping the communities in which they lived. Through conflict, recognition of common values, and shared struggles, a subtle yet profound change occurred: communities became stronger and more vibrant.

Historian Robert Archibald speaks of remembering our past as an act of re-establishing our connection to place and community. He writes, "We all need such places just to know who we are. These are the places where we have created our stories, where we find our shared memories, where we can identify our common ground, the places where we have experienced community and where we can learn to create it again."

It is my sincere hope that these vintage images will allow all readers to make their own connections to community and place and their part in it. Whether native, newcomer, visitor, or returnee, I hope you will find something in this book for you.

One
A Thin Silver Thread
Transportation

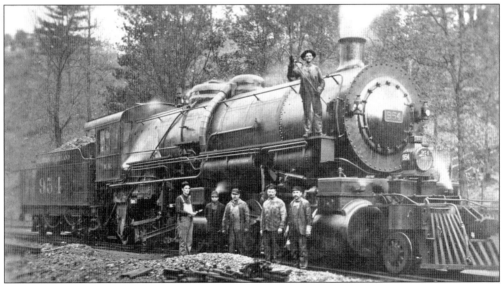

Before 1884, the area between Piedmont and Parsons, West Virginia, was sparsely populated. Along this 70-mile distance, settlers were spread out across the countryside. Difficult travel through the forest was usually made by horseback or on foot. Henry Gassaway Davis built his railroad, the West Virginia Central & Pittsburg (WVC&P), up the North Branch of the Potomac River from Piedmont, West Virginia, to access the timber and coal. And with the railroad came change. (Courtesy Western Maryland Railway Historical Society.)

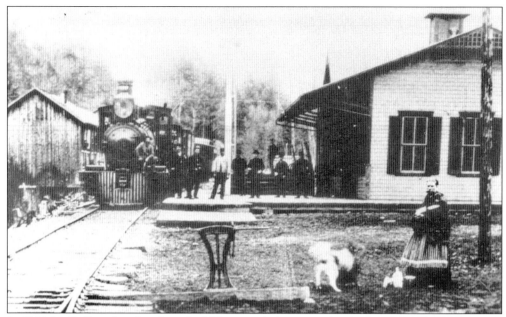

In 1884, H. G. Davis's railroad reached Thomas. A depot was finished in December 1888. Early in 1889, the railroad was completed to Parsons, a distance of 14 miles. This photograph, taken on April 1, 1889, shows the first westbound passenger train to Parsons from Thomas. At this moment, travelers had the option to travel in the relative comfort of a railcar instead of making their way between the towns on muddy, dusty, or bumpy roads.

Three surveys of the Blackwater Canyon were completed before construction began on the grade from Thomas to Parsons. Known as the Black Fork Grade, it was completed in one year's time from 1888 to 1889. It was the steepest in the eastern United States and climbed 1,236 feet in 10 miles. Construction of the Black Fork Grade was considered nearly impossible at the time. (Courtesy Tucker County Historical Society.)

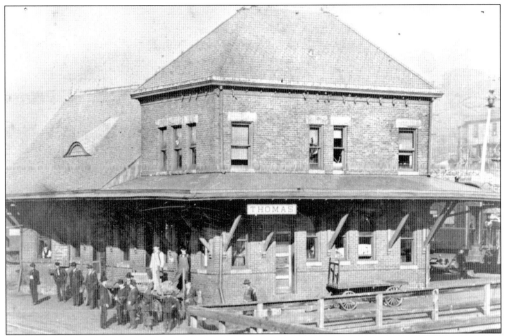

By 1890, Thomas had a newly constructed railroad depot that functioned as a combination passenger and freight station. In 1895, it was enlarged and a second floor was added to house the offices of the West Virginia Central & Pittsburg Railway. This picture shows the building as it appeared in 1900. In 1901, just prior to WVC&P's sale to the Western Maryland Railway, the building was expanded with an addition to the north side.

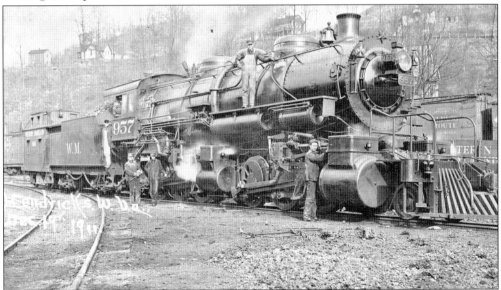

This picture shows Western Maryland Railway's locomotive No. 957 being readied to make its way up the Black Fork Grade from Hendricks in 1911. The sheer size of the locomotive, at 264 tons, made it one of the largest in the world. A contract for the sale of the WVC&P to Western Maryland Railway (WM) was signed on January 4, 1902, ending the era of pioneering railroad history in the region. (Courtesy Tucker County Historical Society.)

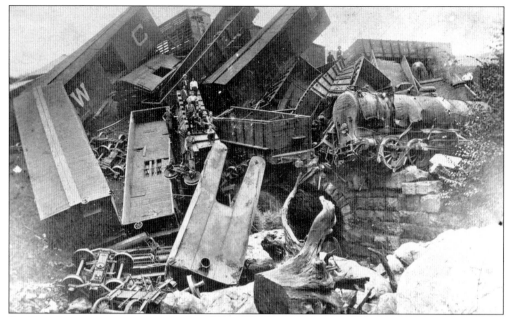

Big Run Curve was a notoriously dangerous spot on the Black Fork Grade. On August 3, 1905, the brakes of WM locomotive No. 103 failed at Douglas. The freight train, propelled by a long line of cars, pushed the cars down the rail line and gained momentum along the way. One of the cars remained on the track and struck an unoccupied caboose in Hendricks. Both the engineer and brakeman were killed in this accident. (Courtesy Western Maryland Railway Historical Society.)

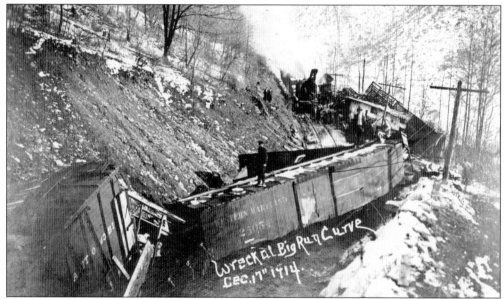

On December 17, 1914, another accident resulted when a locomotive with 33 loaded freight cars ran away at Canyon Point. It wrecked at Big Run Curve, killing brakeman Lee Steerman. Steerman's body was found several days later, covered with several carloads of coal. The engineer and fireman escaped with broken bones, and the rest of the crew was shaken and bruised. (Courtesy Western Maryland Railway Historical Society.)

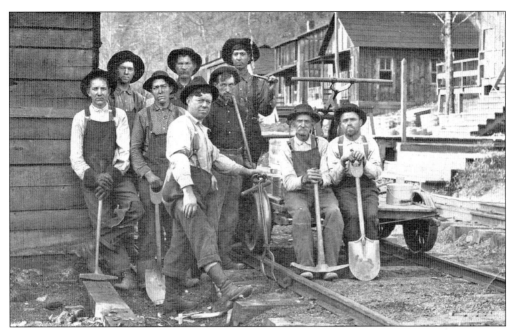

Section crews built, inspected, maintained, and repaired railroad tracks. Crews were crucial in keeping railroads running safely. Members of this Dry Fork Railroad section crew are pictured at Moore Siding around 1913. From left to right are John Fridley, Arthur Reel, Sturley Helmick, Adam McDaniel, William Carr (front, foreman of the crew), Oscar Waybright, Sylvanus Summerfield, "Daddy" Whetsell (age 81 years), and French Carr. (Courtesy David F. Strahin.)

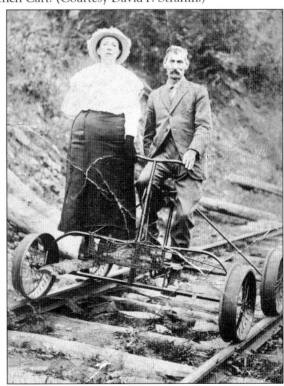

Miss Ame White hitches a ride on a speeder. This bicycle-like contraption allowed railroad maintenance personnel to make close inspections of sections of railroad line and transported work crews and supplies down the track to work sites. At various times in history, it was powered like a bicycle, propelled by pumping a lever up and down, and eventually run by gasoline engines. (Courtesy David F. Strahin.)

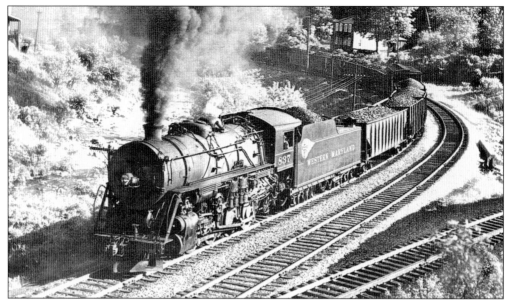

A Western Maryland locomotive crosses over the bridge spanning Snyder Run near Coketon. In 1911, WM constructed a 1.6-mile branch line to the newly formed town of Benbush. The town was named after the WM Railway president, Benjamin Franklin Bush. A horse-operated tramway paralleled the rail line. It was built in 1900 by Dubois and Bond Brothers Lumber Company, which had harvested most of the timber from the area.

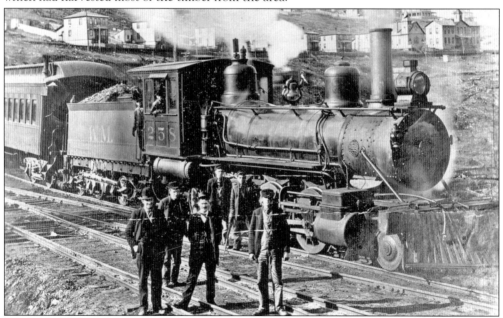

This locomotive sits on the Davis Branch in Thomas c. 1910. In 1884, a 6.3-mile branch of the WVC&P was built from Davis to Thomas, although the two towns were only two miles apart. The branch came down the east side of the North Fork of Blackwater River to a point opposite Douglas and then turned east toward Davis. At one time, five train stations—named Coke Siding, Child, Pendleton, Francis, and Davis—existed along this branch. (Courtesy Western Maryland Railway Historical Society.)

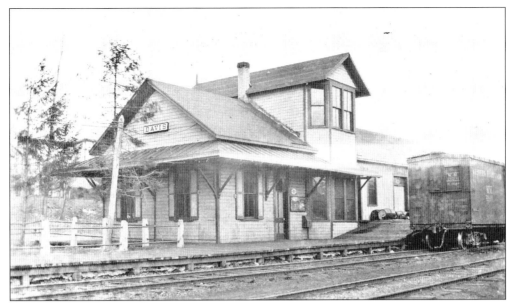

The depot in Davis stood at the center of the bustling town. Passengers, goods, and mail were delivered here. In turn, raw materials associated with the lumber and coal industry waited to depart. Train service started in Davis in June 1885 with two trains daily in each direction. Rail service to Davis was abruptly ended in 1942, despite the protests of the citizens. (Courtesy David F. Strahin.)

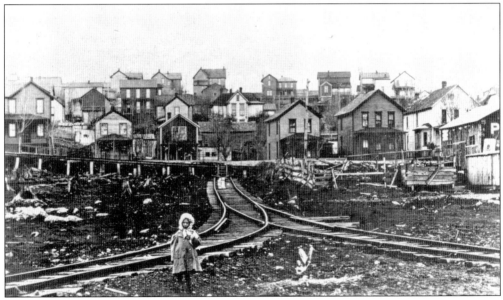

The Davis Branch terminated in town. There was no roundhouse available to turn the locomotives to begin a return trip. In Davis, a wye was constructed in a triangular shape to allow turning of engines. As a train approached town, the engine was uncoupled and proceeded up the tracks in the wye, while the coaches drifted on to the station over a slightly downhill grade. The engine then moved down the main line to the station and backed up to the coaches to ready for the return trip to Thomas. (Courtesy Western Maryland Railway Historical Society.)

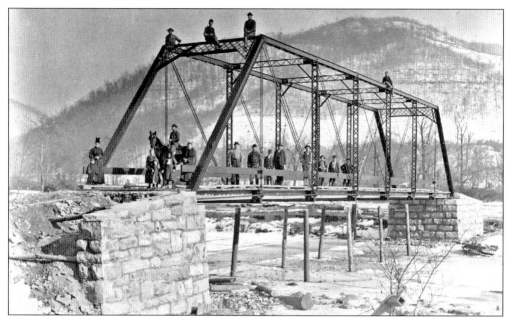

This bridge over Blackwater River at Hendricks was the longest along the Dry Fork Railroad. It was 300 feet long and was built in 1893. Construction of the Dry Fork Railroad began in August 1893, when Robert F. Whitmer, president of the company, drove a spike in the ground in Hendricks, marking the beginning of the railway line. The rail line required 43 bridges and trestles to be built along rugged terrain. (Courtesy Tucker County Historical Society.)

Automobiles brought about a new era of transportation in Tucker County. Pictured here in the 1940s is the old Black Fork Bridge. It was a single-lane bridge spanning the Black Fork River from Bretz to Parsons. The bridge was built in 1901 by the Penn Bridge Company of Beaver Falls, Pennsylvania, at the cost of $12,197. It was replaced by a bridge upstream in August 1943. (Courtesy David F. Strahin.)

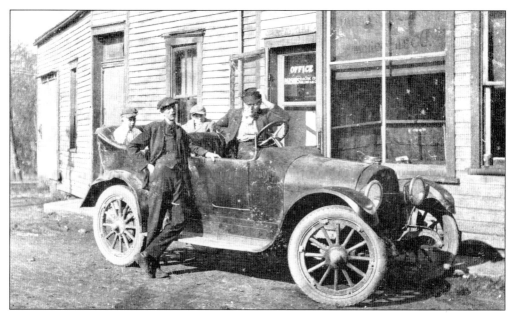

Although the automobile pictured here is not the first car in Tucker County, it might have been one that traveled the first modern roads in the county. The first car assembled in Tucker County was built by mechanic Ralph Rinker around 1902. He was inspired by Richard Shaffer of Baltimore, who traveled by automobile with his wife from Baltimore to Saint George in eight days. Schaffer had built the car himself. (Courtesy Tucker County Historical Society.)

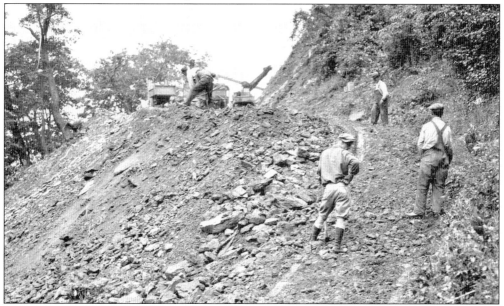

Construction of Route 219 in Tucker County began in 1928. Excitement grew that year when word went out that a new hard-surfaced road would be built from Oakland, Maryland, to Elkins, West Virginia. On October 31, 1929, celebrations were held to mark the opening of a 12-mile section of road in Tucker County. The highway became a reality as a motorcade with city, county, and state officials tentatively snaked their way up the mountain from Parsons. (Courtesy USDA Forest Service, Monongahela National Forest.)

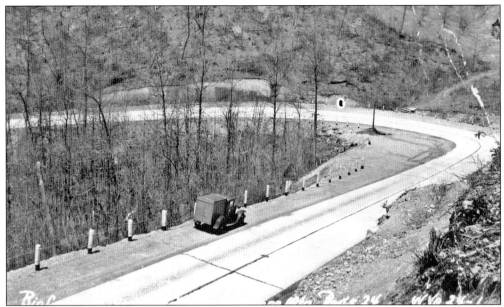

The chief engineer for the Route 219 road project declared, "Anyone can fill hollows and cut off hills, but it takes an engineer to build a road with good curves in it!" Still, some curves required extreme engineering for the day. Curves were elevated by 42 inches, and the roadbed was widened to 22 feet. The engineer must have taken particular delight in building this infamous curve on 219 that locals call "Wild Maggie." (Courtesy David F. Strahin.)

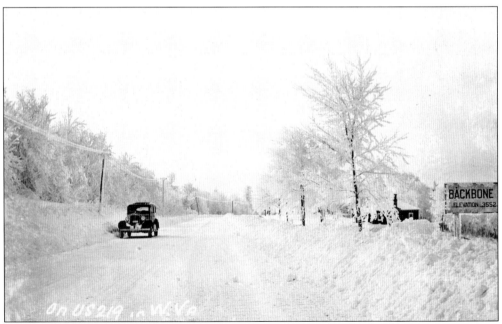

This point on Backbone Mountain (elevation 3,552 feet) is one of the most notoriously dangerous and changeable weather spots on Route 219. On any given day, travelers can experience wind, snow, sun, fog, and rain, sometimes all in the same day! There are both challenges and rewards of driving this beautiful section of highway. (Courtesy David F. Strahin.)

Two
OFF THE MOUNTAIN
Parsons

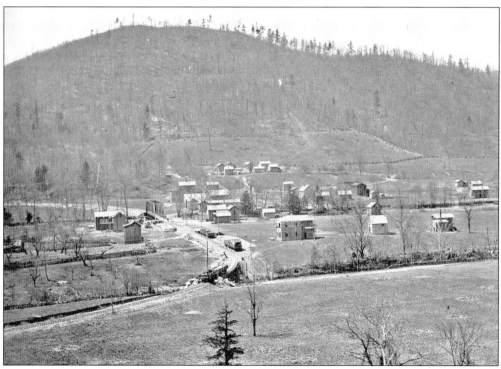

This early picture of Parsons was taken in April 1889 from a point high above Black Fork River. Construction of the West Virginia Central & Pittsburg Railway has reached the area. Flooding in 1888 had impeded the progress of the railroad to Parsons, but signs of progress show in this photograph with newly constructed bridges spanning Shavers Fork and the millrace. Parsons was overtaking its neighbors in the Cheat River valley, shifting power away from a largely agricultural economy to one centered on industries for processing the vast timber resources. At the time of this photograph, Parsons had around 50 inhabitants. Just five years later, Parsons was incorporated and the new seat of Tucker County. (Courtesy Tucker County Historical Society.)

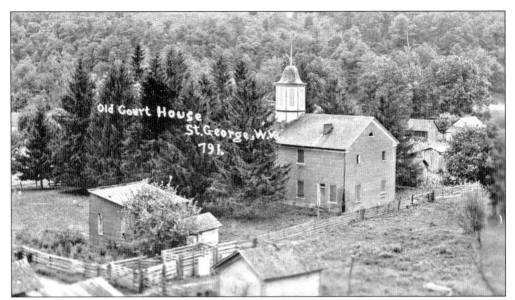

Construction of the courthouse in Saint George began in 1858 and was completed in 1859. Tucker County had come into existence in 1856, having been carved out of Randolph County, Virginia. The handsome structure was made of locally fired bricks topped by a graceful bell tower. In August 1893, after months of contentious debate and contested elections, courthouse records, equipment, and even the bell from the tower were forcibly moved to Parsons. The courthouse in St. George stood neglected for almost 30 years before it fell to ruin. (Courtesy Dorothy Thompson.)

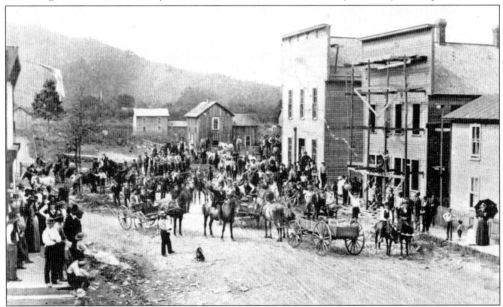

Courthouse records and equipment taken from Saint George arrived in Parsons on Wednesday, August 2, 1893. This picture was taken on Main Street as the group of courthouse pirates arrived victorious in Parsons. Whether these men were considered a "mob" or proactive citizens remains a matter of historic interpretation. The balance of power in the county was altered on that day, making Parsons the new administrative center of the county. (Courtesy Tucker County Historical Society.)

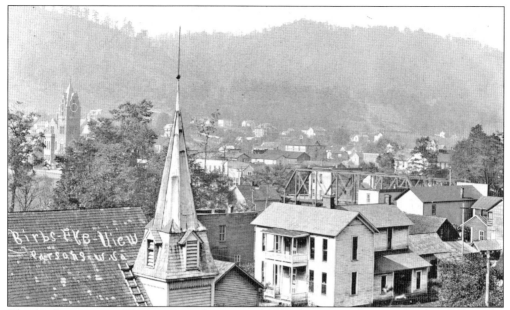

This bird's-eye view of Parsons was taken around 1900 from somewhere on Quality Hill. In the distance at left, the empty clock tower of the new county courthouse can be seen. After almost 20 years of lost time, the clock was finally installed. Funds for its purchase and installation became available with the passage of the National Prohibition Amendment of 1920. Collection of fines from illegal moonshine and bootlegging operations provided the money needed to purchase and install the clock. (Courtesy Dorothy Thompson.)

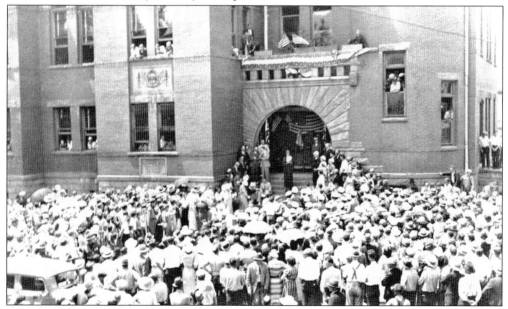

Designed by architect Frank Milburn in 1898, the Tucker County Courthouse was ridiculed by many as too costly and unattractive. However, it became the symbolic center of county life. Eleanor Roosevelt's visit to Tucker County is captured in this photo from the 1930s. Residents were also part of the procession that ended at the courthouse steps and included inductees of World Wars, Memorial Day ceremonies, and cake walks. (Courtesy Tucker County Historical Society.)

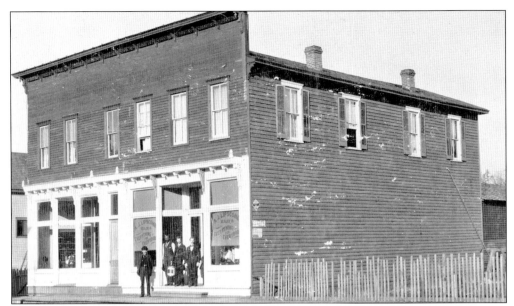

The Diamond Mercantile Company, a large general store on Walnut Street in Parsons, was formed in December 1897. Handling a variety of merchandise, the store provided "Everything for Everybody," as the advertising slogan on the window boasts. The Shaffer and Lipscomb families combined their three stores in 1897 in this building owned by Creed W. Minear. A devastating fire broke out on May 15, 1899, and sustained $20,000 in damages to the business and homes on Walnut Street. (Courtesy Tucker County Historical Society.)

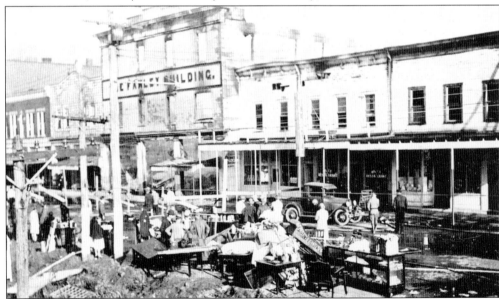

The Fawley Building on First Street burned in the early morning hours of May 21, 1932. This large, three-story concrete building was supposedly fireproof. Responding to the fire were the Elkins and Thomas fire departments. They were notified by Western Union wire service because the telephone exchange located in the building was destroyed. Adjacent buildings also sustained extensive damage or were completely destroyed, and two firemen were injured. The fire caused $50,000 dollars worth of damage. (Courtesy West Virginia State Archives.)

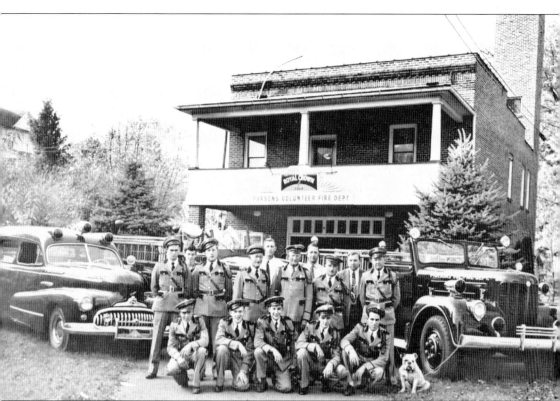

The Parsons Volunteer Fire Department was organized on May 22, 1932. Its formation was prompted by the devastating Fawley Building fire, which had occurred the previous day. Extensive property losses spurred the decision to form and equip the department. Parsons VFD was motorized in the spring of 1933 with the purchase of a new American LaFrance pumper. Meredith Swearingen, the first motorized fire chief, served in that capacity until 1941. Darl Stalnaker served as fire chief several times over during the 1940s and 1950s. Included in this picture of the Parsons Volunteer Fire Department and Fire Hall, *c.* 1946, are Richard Agee, Calvin Bohon, Bill Harlow, mascot Duffy, Bud Lanham, Ross Mareney, ? Davis, ? Mitchell, Jim Smith, Darl Stalnaker, David Gatrell, ? Martin, and Ron Sheets. (Courtesy Tucker County Historical Society.)

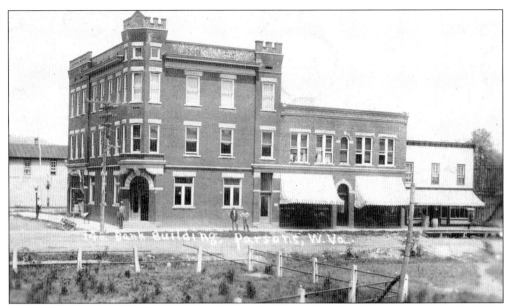

Tucker County Bank opened for business in June 1900. The bank conducted business in the Tucker County Courthouse until it found its permanent home at the corner of First and Walnut Streets in 1904. Local attorney Lloyd Hansford was the bank's first president. It opened with 32 stockholders and remained one of the cornerstones of the banking business in the county for many years. (Courtesy Tucker County Historical Society.)

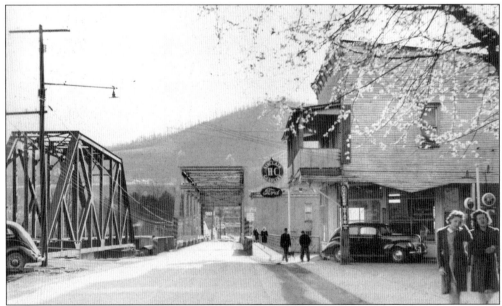

Parsons is located near five rivers: the Blackwater, Dry Fork, Black Fork, Shavers Fork, and Cheat Rivers. Because of this, Parsons earns its nickname "River City." Bridges are an essential feature of the city, connecting it to other places. This photo, taken sometime in the 1940s, shows the two bridges on Shavers Fork, just east of town. Arbogast Brothers Garage is pictured on the right, just west of the bridge on First Street. (Courtesy David F. Strahin.)

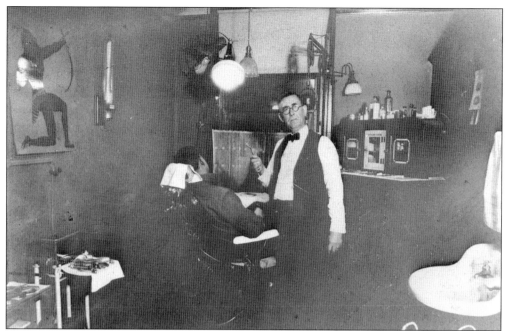

Dentist O. A. Miller works on his son Wallace sometime in the early 1930s. Dr. Miller sent out "Season's Greetings" in this advertising piece. Miller practiced in Parsons and had offices on the second floor of the Tucker County Bank Building. (Courtesy Tucker County Historical Society.)

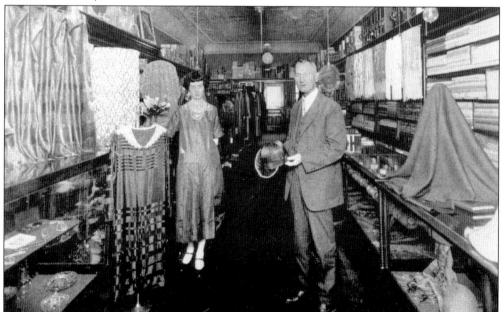

One of the most fashionable shops in Parsons was Wilfong's Ladies Apparel on First Street. Faye and Haymond Wilfong are pictured in this photograph from around 1920. The shop offered off-the-rack dresses in the latest styles and accessories such as hats, jewelry, fringed shawls, and fancy trims that completed any women's wardrobe. What need was there to go to Elkins? (Courtesy West Virginia State Archives.)

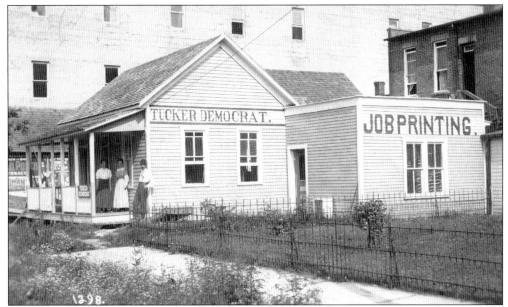

At the time of this photograph (1910), the *Tucker Democrat* was the oldest newspaper in the county. It got its start at Saint George around 1880 and moved to Parsons in 1893. In a 1906 advertisement, editor and publisher George Dean promised "fearless, newsy, and spicy" reporting. The newspaper survived several name changes and continued to deliver news to Tucker Countians until 1954. (Courtesy Jane Barb.)

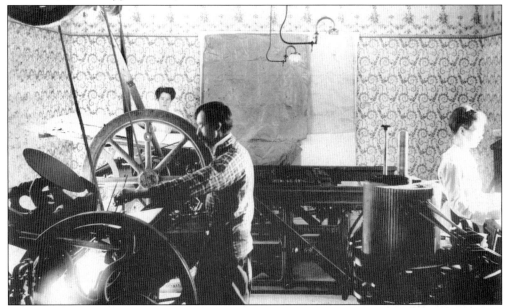

The Mountain State Patriot, established at Parsons in 1902, was edited by J. W. Bedford. Bedford was a longtime chairman of the West Virginia Prohibition Party and once a candidate for governor. Bedford's newspaper solidly reflected Prohibitionist beliefs. In this *c.* 1909 photo, Bedford's son James Abraham Garfield Bedford runs the press, while Rose (Hebb) Davis looks on (right). The press stood by its claim to do "all kinds of printing–except bad printing." (Courtesy West Virginia State Archives.)

The First Baptist Church of Parsons was organized in 1891. For 15 years, the congregation met at homes and locations around town. It wasn't until 1900 that the church found a permanent home on Water Street. Donations of materials were received from church members and businesses in surrounding area. The church was dedicated in 1906, led by Rev. C. H. Pack, the church's first pastor. (Courtesy David F. Strahin.)

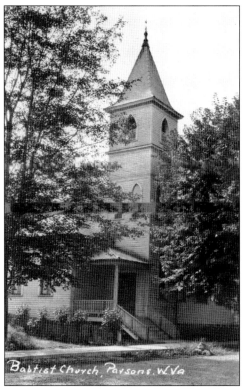

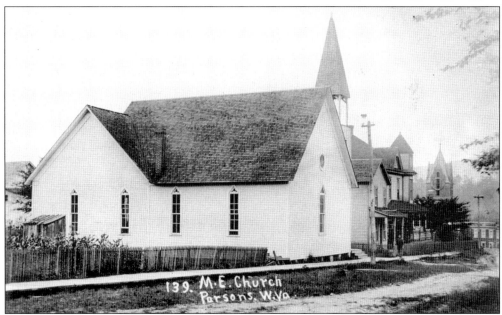

The congregation of Methodist Episcopal South Church was the first to erect a church building in Parsons. This church stood from 1870 until 1887 when it burned. Five years later, a new sanctuary for the Methodist Episcopal North congregation (shown here around 1906) was built on First Street Hill. Its first minister was Rev. Arthur Chambers. In the church's tower was the bell (see page 20) from the old courthouse in Saint George. (Courtesy West Virginia State Archives.)

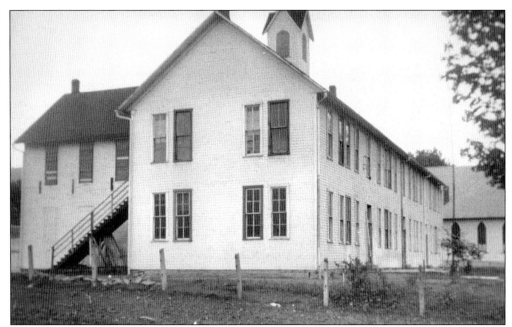

In the 1890s, Parsons experienced a boom in its population. A four-room schoolhouse was constructed at the corner of Water and Second Streets in the summer of 1894 to accommodate a growing school-aged population. Six additional rooms were added onto the main structure over the course of a 15-year period. The wood-framed building remained in service as a grade school until 1939. (Courtesy Tucker County Historical Society.)

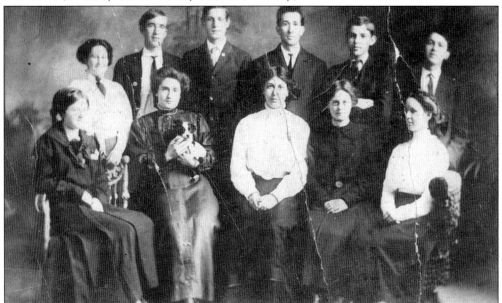

Classes for a one-year high school were inaugurated in Parsons in 1909 and were conducted at the grade school on Water Street; the first class graduated in 1910. Members of the 1910 graduating class are, from left to right, (front row) ? Bond, Hazel (Hulings) Graham, Bertie Shrout, Madge Long, and Zella Valentine; (back row) Mabel Ryan, Paul Dudley, John Kuh, Harvey Auvil (teacher and principal), Ernest Angelo, and Harry Fawley. (Courtesy David F. Strahin.)

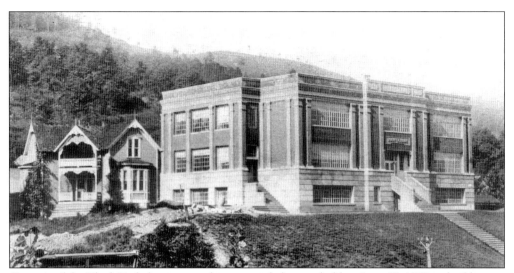

Citizens of the Black Fork district voted in a special election held on June 19, 1912, to build a new high school, which would cost $35,000. The building was completed in December 1913 and stood above Chestnut Street between Second and Third Streets. It contained eight regular classrooms, two laboratories, a manual arts training shop, large auditorium, and library. Classes commenced on January 5, 1914. (Courtesy West Virginia State Archives.)

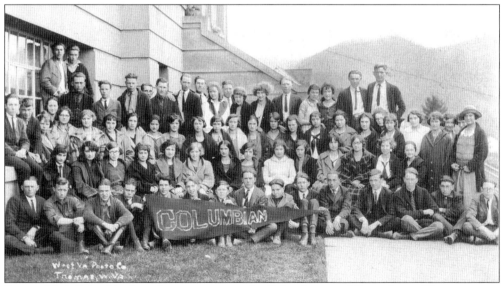

Parsons High School had two literary societies, the Columbians and Corinthians. These societies provided a creative and competitive outlet for students. Regular programs during the week showcased students' abilities in short plays, musical performances, and readings and recitations. At Parsons High School, the societies also created a social dividing line of students. The Columbian Society was composed of out-of-town students from Hambleton, Hendricks, Porterwood, and Montrose who lived in town and paid room and board while attending high school. (Courtesy Tucker County Historical Society.)

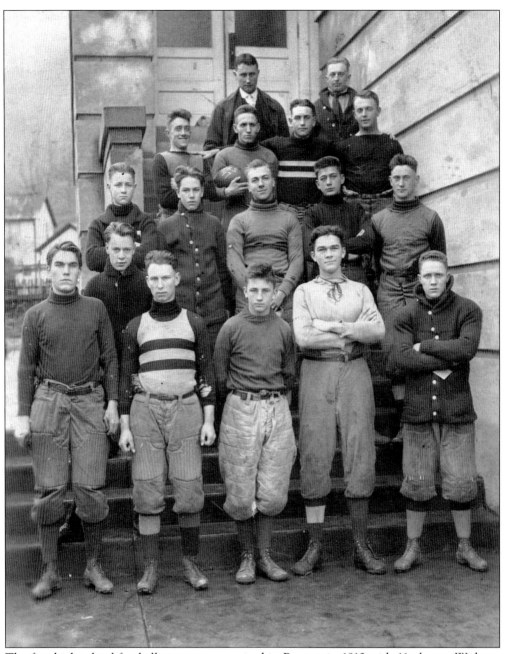

The first high school football team was organized in Parsons in 1912 with 11 players. With no substitutes and just enough to field a team, players continued to play even when injured. The team took on local high school teams as well as local college teams from Davis and Elkins College in Elkins and Broaddus College in Philippi. By the time this picture was taken (1917), the ranks of the newly formed Black Fork District High School football team had swelled to over 15. (Courtesy Tucker County Historical Society.)

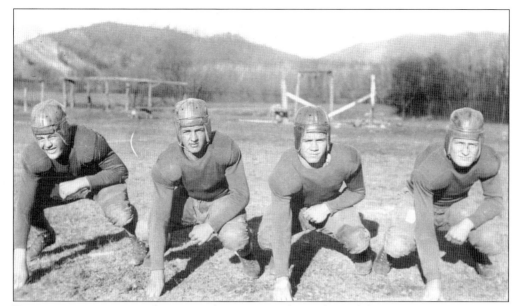

Equipment improvements show up in this picture with members of the 1933–1934 Parsons High School Panthers football team. Lux Vachon, Woody Bowley, Joe Gilmore, and Jim Parsons are pictured from left to right. That same year, the school's basketball team won the state championship, defeating Elkins in the finals with a score of 33-30. Bowley and Gilmore were guards on that championship basketball team. (Courtesy Tucker County Historical Society.)

This photograph was taken at a sectional track meet in Elkins in May 1921, where the Black Fork District High School team from Parsons was competing. Boosters show their school spirit and determination by cheering for their home team: "Kick 'em in the shins, kick 'em in the jaw, cemetery, cemetery, rah, rah, rah!" (Courtesy Tucker County Historical Society.)

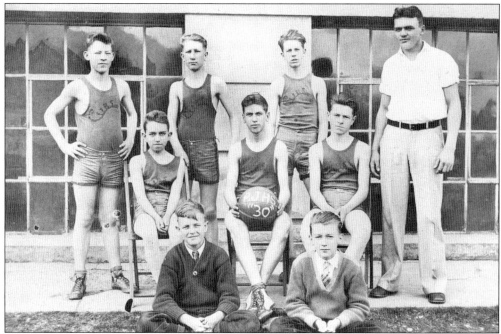

Some of the youth of this sports group later became part of the Parsons High School basketball team that won the West Virginia State Basketball Championship in 1934. Pictured in 1930 on the Cubs team are, from left to right, (front row) Junior Digman and assistant manager Winny Haines; (middle row) Lewis Perry, captain Elmer "Jonie" Shrout, and manager Sam Hehle; (back row) Russell Spangler, Ted Conaway, Charles Auvil, and coach Earl "Dad" Parsons. (Courtesy Tucker County Historical Society.)

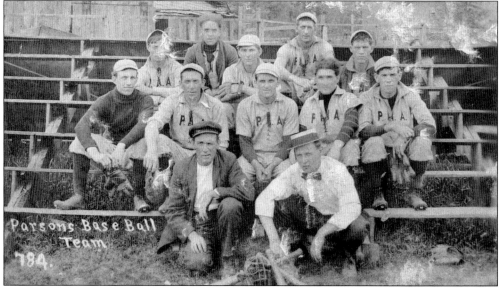

Community groups organized baseball teams that competed against those representing the major industries in Parsons. There were four teams in Parsons at the time of this 1909 photograph. Competitors included the Planing Mill team, the Mulley Grubs, the Independents, and the Pulp Mill team. (Courtesy Tucker County Historical Society.)

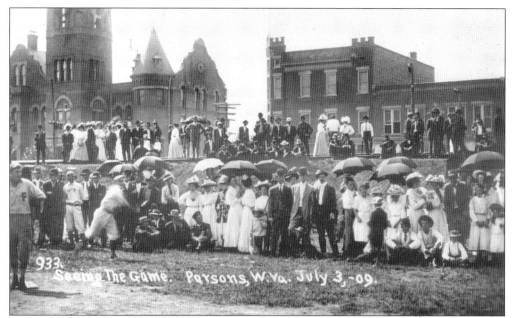

A baseball game against Davis was part of Parsons's Fourth of July celebrations in 1909. Spectators look on from the Western Maryland rail grade in town. Men huddle around the Davis pitcher as he warms up. Ladies look out from under umbrellas shielding them from the sun. All this takes place in the shadow of the Tucker County Courthouse. (Courtesy West Virginia State Archives.)

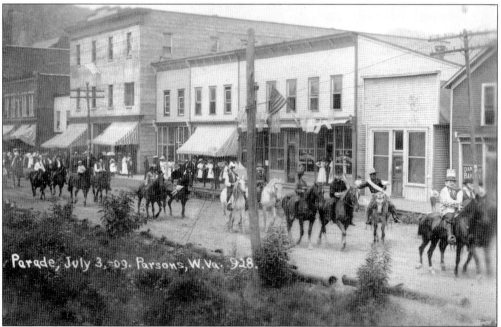

Parsons celebrates Independence Day on July 3, 1909. A mounted brigade of masked riders portraying cowboys and Indians and Uncle Sam joined floats, Ethiopian comic performers, the Mountain City Band of Davis, and the Parsons City Band. G. H. Broadwater, a photographer with a studio in Thomas, chronicled several holiday celebrations during July 3–5, 1909, including celebrations in Thomas on July 5 (see page 49, upper right). (Courtesy Tucker County Historical Society.)

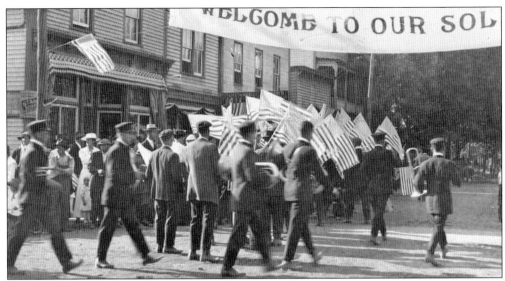

Five hundred and sixty Tucker County men served in the military during World War I. Tucker County signed up a total of 1,505 men for military service during the first period of registration ending June 5, 1917. The first call for young men was on September 20, 1917, when 66 Tucker County men were taken, according to the September 20 issue of the *Parsons Advocate*, to Camp Lee, Virginia, for training. A parade in their honor preceded their departure from Parsons. (Courtesy Jane Barb.)

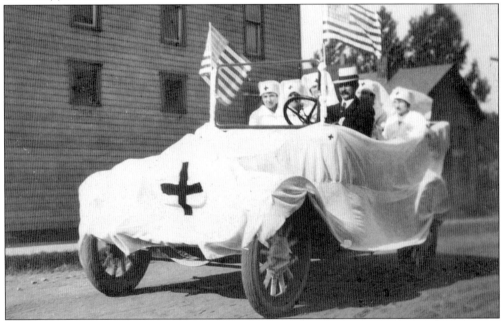

This Fourth of July parade in 1918 took on special significance during World War I. The parade was planned to benefit the Tucker County chapter of the American Red Cross and honor "the Boys over there," according to a local newspaper advertisement. Represented in the parade were bands, fraternal organizations, church groups, United States veterans and veterans of its World War I allies, county and local Red Cross organizations, Boy Scouts, and Union and Confederate Civil War Veterans. (Courtesy Jane Barb.)

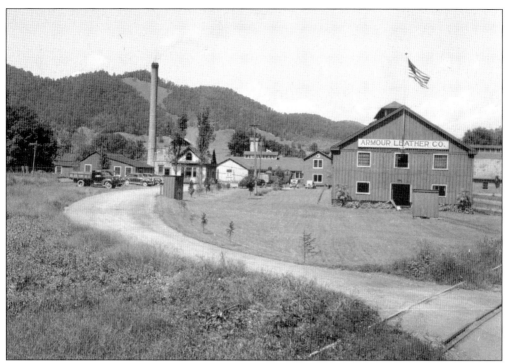

The Milton Tannery in Parsons started operations in 1893 and was managed by Thomas Gould. Ready access to bark from local hemlock and chestnut oak trees made locating the industry in Tucker County a natural choice. The bark from these trees was ground or boiled, and the resulting liquid was used to tan animal hides for leather. The tannery changed hands several times before being sold to the Armour Leather Company in the 1930s. (Courtesy David F. Strahin.)

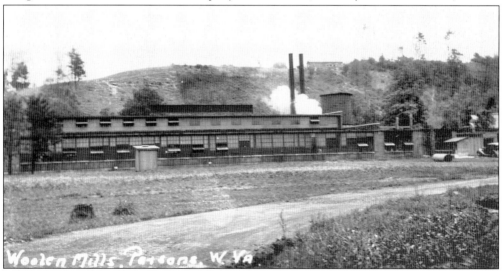

The textile industry came to Tucker County in 1922 when the Hall brothers of Philippi built a mill in Parsons. They owned a similar mill in Philippi, and both were called the Philippi Woolen Mills. In 1924, both went into receivership and were eventually acquired by the Dorman brothers of New York City. The mill was incorporated in February 1927 and provided hundreds of jobs in its decades of operation. (Courtesy Tucker County Historical Society.)

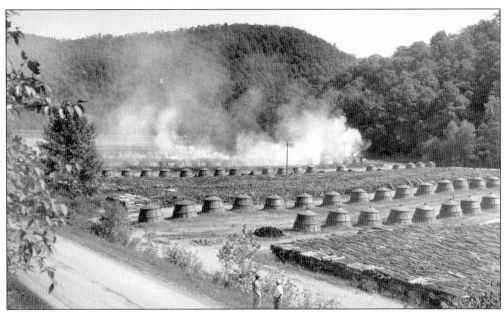

This picture from September 1959 shows Kingsford charcoal kilns at the intersection of Routes 38 and 72 near Saint George. Wood inside the kiln was first fired at a high temperature. The kiln was then plugged at the top and dirt was piled around the base of the structure to control the burn temperature. Once the product had cooled, the kiln was lifted off to retrieve the charred product inside. This material was then sent to the Kingsford plant in Parsons for further processing. (Courtesy USDA Forest Service, Monongahela National Forest.)

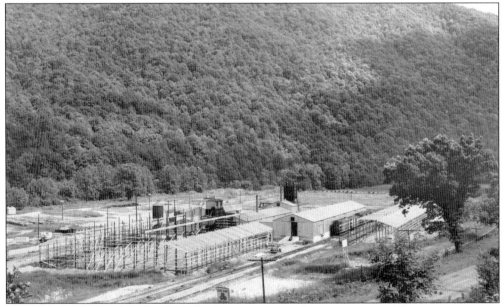

This photograph, dated August 15, 1959, shows warehouses being constructed for expansion to the new Kingsford plant. The Kingsford Company came to Parsons from Iron Mountain, Michigan, in 1958. Kingsford gradually phased out startup operations like the one pictured above. Production was then concentrated in Parsons, with the company's charcoal briquettes being produced at the main plant. (Courtesy USDA Forest Service, Monongahela National Forest.)

Three
DOWN BY THE RIVERSIDE
Hambleton and Hendricks

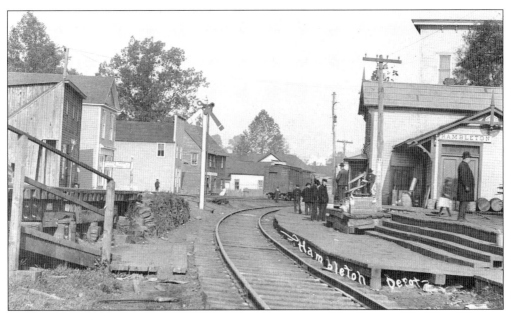

Men wait on the platform for the next train to arrive in Hambleton. The West Virginia Central & Pittsburg Railway reached the town in 1889 when it was called Hulings. This name originated from the time of the establishment of the Hulings Lumber Company. The town was renamed in 1899 in honor of John Hambleton, a director of the West Virginia Central & Pittsburg Railway. Hambleton remained a major commercial center for many years. The Otter Creek Boom and Lumber Company sustained Hambleton's economy from 1897 until 1914. (Courtesy Dorothy Thompson.)

John A. Hambleton, boyhood friend of H. G. Davis, became a director and stockholder of Davis's railroad, the West Virginia Central & Pittsburg Railway. He also was an influential banker in Baltimore and headed up John A. Hambleton and Company, a well-heeled group with close ties to Davis. In 1889, the railroad reached the town, bringing boom times to the area. (Courtesy Tucker County Historical Society.)

Hambleton is the second oldest settlement in Tucker County, having been settled by John Rush and his wife, Eve, in the late 1790s. Since 1783, this place has been known by a succession of names: Rush's, Goff's, Goff Town, Black Fork (around 1858, a post office was established in the area called Black Fork Post Office), Hulings (from 1888 until 1905), then incorporated as Hambleton in 1905. (Courtesy Tucker County Historical Society.)

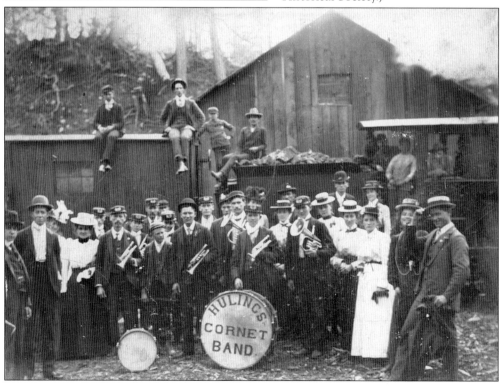

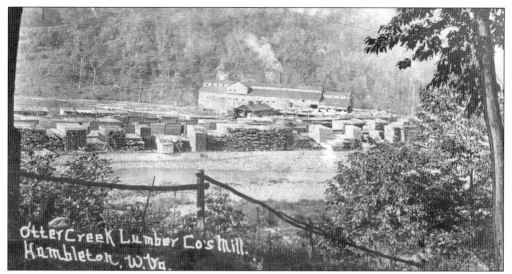

The Otter Creek Boom and Lumber Company operated from 1897 to 1914. At the peak of production, the company employed around 500, and the mill could cut an average daily capacity of 150,000 board feet. Located on 20 level acres across Black Fork River from Hambleton, the mill and yards were accessible by a standard-gauge railroad bridge. The company owned timber lands in Tucker and Randolph Counties. (Courtesy Tucker County Historical Society.)

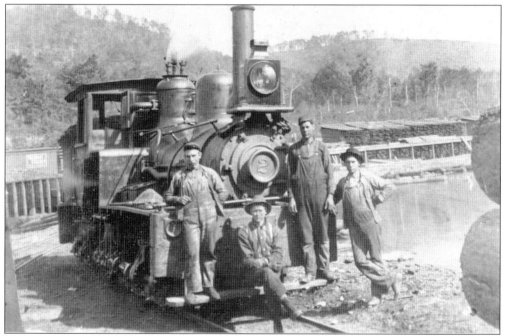

Shay No. 2, owned by Otter Creek Boom and Lumber, is pictured here in 1902. Shay engines were specialized locomotives designed for logging service and were well-suited to rough and hilly terrain. Otter Creek Lumber used the Shay in their operations to access timberlands on Green and McGowan Mountains and along Otter Creek. Shays provided stability, traction, and efficiency with minimum locomotive weight. (Courtesy Western Maryland Railway Historical Society.)

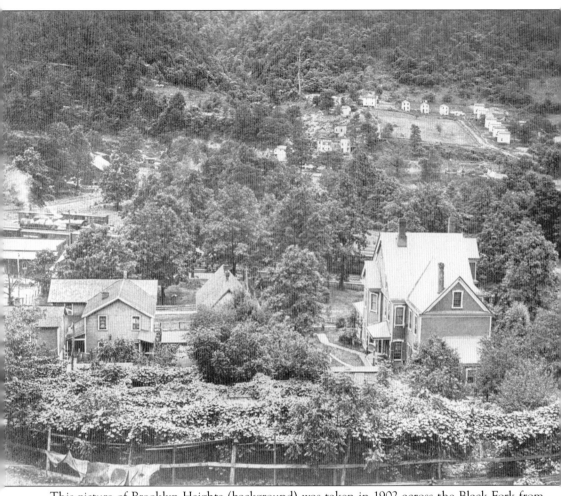

This picture of Brooklyn Heights (background) was taken in 1902 across the Black Fork from Hendricks. Charles Darwin Gillispie built the town after Hendricks voted itself "dry" in 1901. Gillispie had attempted to establish a saloon in Hendricks before the vote. After the vote, he built a swinging bridge to land he had purchased to establish Brooklyn Heights. Sixteen dwellings were constructed, which Gillispie offered rent-free to tenants. Gillispie was Brooklyn Heights's designer and biggest promoter, offering it as an alternative to Hendrick's straight-laced ways. In a special election in 1901, the town voted itself "wet." Gillispie obtained a liquor license from the town and opened the Cream of Kentucky saloon. The Town of Brooklyn Heights incorporated on June 14, 1902. The corporation line extended down the river far enough to include the tannery and sawmill so that municipal taxes could be collected from these firms. Otter Creek Boom and Lumber Company railroad passed directly through the town, along the notorious main street, Bedbug Lane. (Courtesy Tucker County Historical Society.)

A baseball game is in "full swing" on Hambleton Leather Company's field in 1914. Life in the lumber camps and coal mining towns was rough and tumble, and workers found ways to blow off steam in off hours. Many of these communities vied with each other to recruit the best players and formed baseball teams of semi-professional caliber. (Courtesy Tucker County Historical Society.)

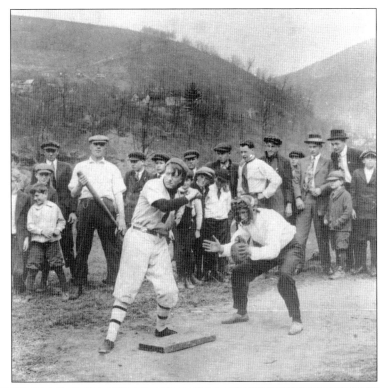

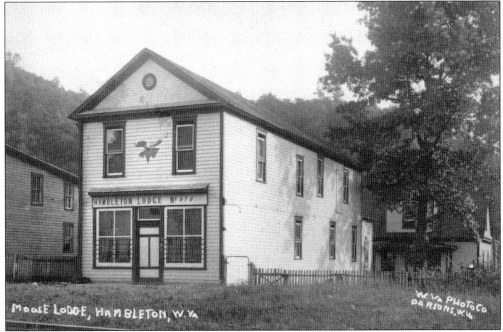

The Loyal Order of Moose fraternal organization erected a large building in Hambleton in the early 1900s. It functioned as a recreation hall and banquet room for approximately 20 years and was dismantled around 1940 when the membership of the lodge dipped so low that it was forced to merge with the one in Parsons. (Courtesy Tucker County Historical Society.)

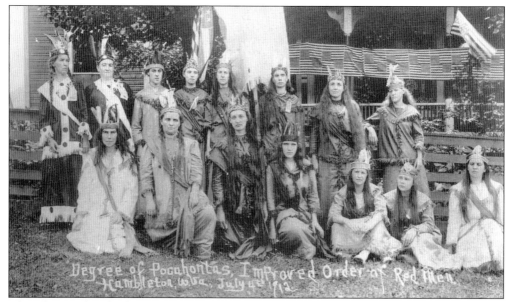

This photo is dated July 4, 1912, and was taken in Hambleton. These women belonged to the Degree of Pocahontas, an affiliate of the Improved Order of Red Men. IORM is patterned after the democratic Iroquois Confederacy and can trace its origins to before the American Revolution. The Degree of Pocahontas patterns itself after the virtues of this Native American princess—virtues of kindness, love, charity, and loyalty to one's own nation. (Courtesy Tucker County Historical Society.)

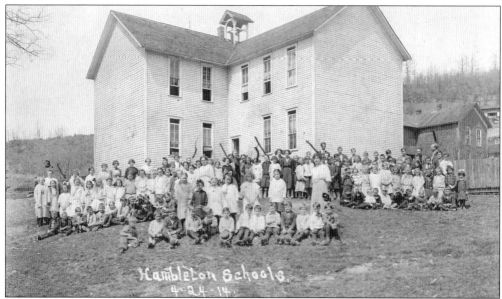

All grades of the Hambleton School are assembled for this school picture in April 1914. Mr. ? Coontz was principal of the school, and W. K. Collett and Mrs. ? Harman were the teachers. The first school in Hambleton was a one-room building erected in 1890. A growing population and a relatively prosperous economy led to the construction of a six-room school located on the same site. The schools of neighboring Hambleton and Hendricks merged in 1940, with students coming under one roof midway between the two towns. (Courtesy Tucker County Historical Society.)

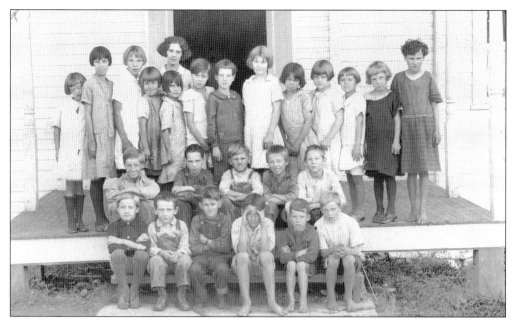

The Hambleton School group is pictured here in 1927. Included are William Roberts, Jack Griffith, Roy Young, Frank Vachon, Jimmy Murray, ? Rhoades, Jack Roberts, ? Rhoades, Russell Mason, ? Elyard, Russell Tuesing, Hazel Mason, Pauline Paugh, Helen Rhoades, Maxine Sponaugle, Esther Paugh, Mildred Combs, Ruth Weaver, Sylvia Paugh, Alice Degler, and Margaret Cochran. (Courtesy Tucker County Historical Society.)

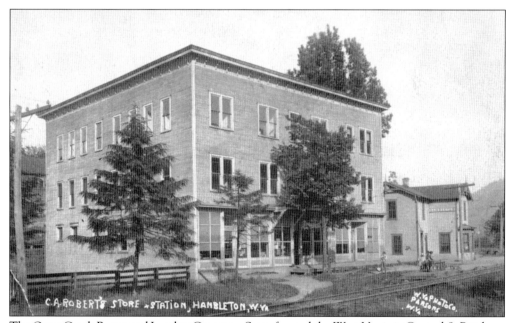

The Otter Creek Boom and Lumber Company Store fronted the West Virginia Central & Pittsburg Railway in Hambleton. The property was acquired by Charles Ashton Roberts Sr. in 1915 and was operated by Roberts until his death in 1933. His son, Charles Ashton Roberts Jr., dismantled the building and erected a smaller store on Route 72. (Courtesy Tucker County Historical Society.)

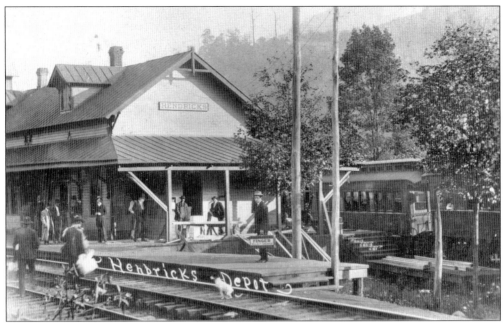

Hendricks was at the intersection of much activity and offered many of the same goods and services of larger towns. The town had banks, hotels, restaurants, opera and movie houses, drug stores, a photography studio, and clothing stores. Due to its competitive business climate, catchy and innovative advertising had to be employed. Salesman Mike Finger is pictured at the depot in Hendricks with his suitcase that claimed, "Finger Sells it Cheapest." (Courtesy Western Maryland Railway Historical Society.)

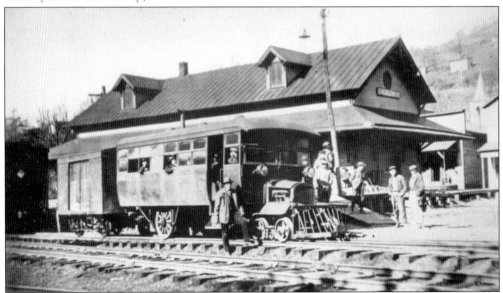

Passengers wait for their trip to get underway. This coach, called a jitney, was adapted by Central West Virginia & Southern for passenger traffic and had the appearance of a rail bus. A baggage car, or doghouse (shown here), was attached to allow more spacious accommodations in the cab. Thad Harper waits by the cab of the jitney on the platform of the Hendricks Station. (Courtesy David F. Strahin.)

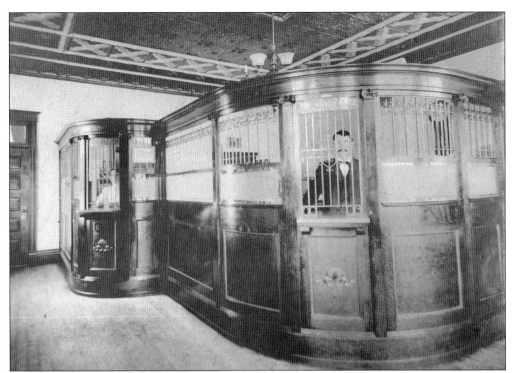

Cashier Creed Minear is pictured at the First National Bank of Hendricks, which opened its doors in 1905. Officers of the bank were B. Worth Jennings, president; Lewis C. Dyer, vice-president; Creed W. Minear, cashier; and Rufus J. Clifford, Charles W. Mosser, A. J. Armstrong, Jacob E. Poling, J. W. Knopsnider, and T. Raines, directors. (Courtesy Tucker County Historical Society.)

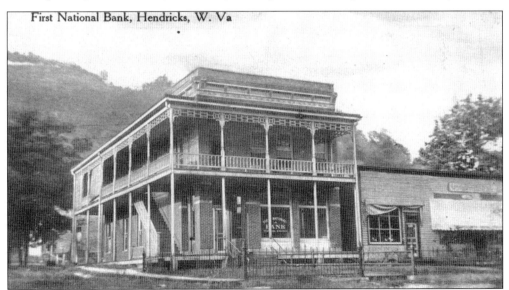

The Bank in Hendricks had its own currency, as did the First National Banks of Parsons and Davis. Confidence in these banks was severely eroded during the Great Depression of the 1930s. Only the Hendricks bank closed its doors, with shareholders electing to voluntarily merge their assets with the First National Bank in Parsons in 1936. (Courtesy David F. Strahin.)

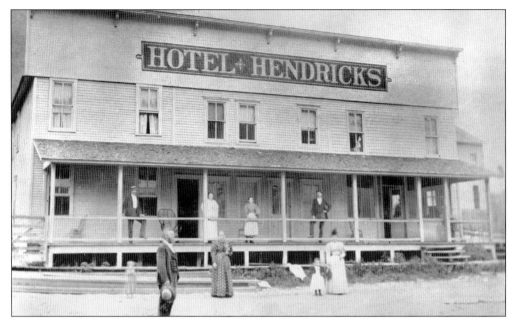

Hotel Hendricks was built in 1892 by Adam Harness Harper (1843–1931), who had come from Pendleton County, West Virginia. It was the first hotel in Hendricks and stood along Route 72. Harper constructed the reservoirs and waterworks for Hendricks in 1898. He had the first bath tub in Hendricks. Hotel Hendricks was later operated by Nellie Smith Price and was torn down about 1917. (Courtesy Tucker County Historical Society.)

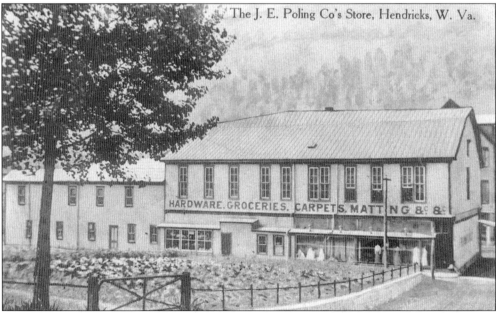

Jacob Elliott Poling (1865–1954) came from Barbour County in 1888. He was partner in several general mercantile businesses in Hendricks during the next 20-year period. In 1907, J. E. Poling & Company was incorporated. Occupying around 25,000 square feet, the store sold "everything from peanuts to automobiles" and also housed a post office, railway station, and express office. At one time, the company employed 33 people. (Courtesy Tucker County Historical Society.)

Four
ON THE MOUNTAIN
Thomas

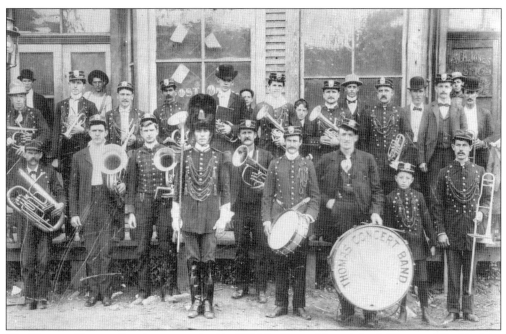

The Thomas Concert Band was organized in 1900. In Trevey Nutter's book *Thomas, West Virginia*, the author indicates that the band was reorganized in March 1905. Although not in order, some of the band members in this 1906 picture might be identified by the instruments that they are playing: Joseph A. Rexroad, leader and coronet; Peter Dornon, coronet; Riley Tice, coronet; Roy Davis, coronet; Ambrose Davis, coronet; John Russell, alto; James Hawkshaw, alto; Frank Pelican, alto; Albert Topper, trombone; Walter Phillips, baritone; Arch Stuart, bass; Evert Manley, snare drum; and Clyde Schooly, base drum.

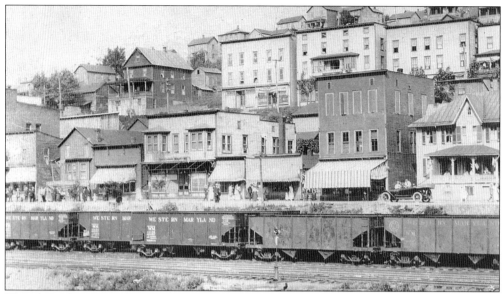

This photo shows storefronts along Front Street around 1920. In August 1884, the West Virginia Central & Pittsburg Railway arrived in Thomas. A coal mine had been opened the previous winter, and coal was ready to be loaded onto cars for shipment to eastern markets. Within the next decade, Thomas "boomed." By 1892, when the town of Thomas was incorporated, the population was 693. In 1920, the town officially became a city and had a population of 2,099. (Courtesy Tucker County Historical Society.)

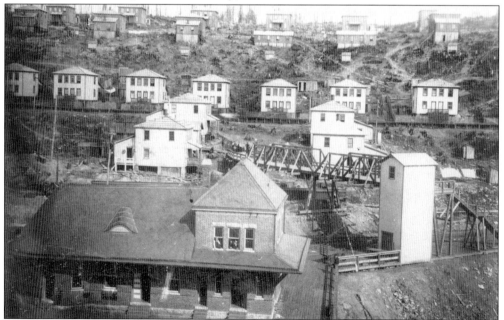

Pictured in 1903, the depot usually was the first stop for most travelers, their baggage, and other freight arriving in Thomas. Until 1925, there was no road that went directly to the depot, making it difficult to access the platform. A hand elevator (pictured right) and an elevated walkway was the only way that bulky items could be transferred to and from the depot. Passengers used the stairway. (Courtesy Western Maryland Railway Historical Society.)

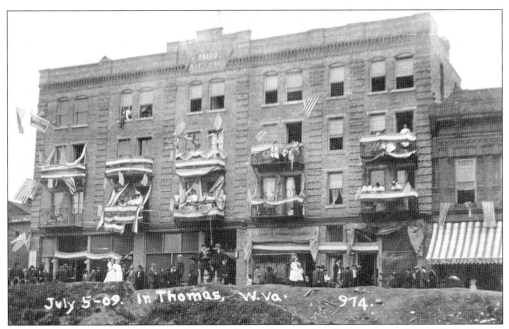

The R. D. Benedetto Building in Thomas is shown decorated with bunting on July 5, 1909. Known to many residents as "The Flats," it was simply called "home" by many families and individuals in Thomas. This photograph, taken soon after the building was constructed, shows the wrought-iron balconies that overlooked the Western Maryland Railway line. No doubt this beautiful building was part of many people's first memories of the town. (Courtesy Jane Barb.)

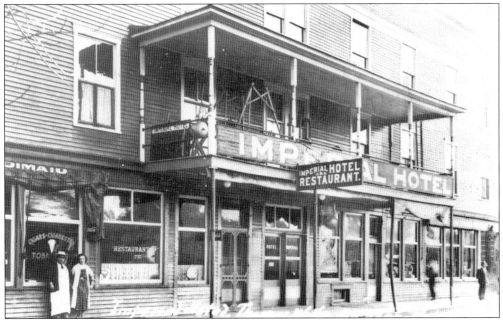

The Imperial Hotel on Front Street in Thomas opened its doors in 1902 under the name Hotel Metropolitan. The Metropolitan was the finest and largest hotel in Thomas. It was owned and operated by Mrs. Mary Geisberger and served visiting businessmen and railroad officials with fine food and lodging. At various times, the hotel housed different businesses and apartments.

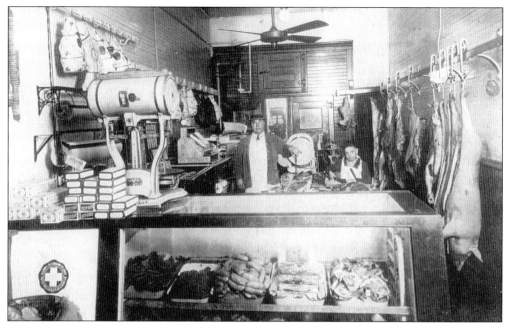

Thomas's Front Street had many mom-and-pop type operations. Mike Ferruso's was one of the local businesses that operated for many years along the busy street. Ferruso poses with his stock and trade: cured and fresh meats sliced any way you liked, along with eggs, cheese, pepperoni, and salami. Ferruso was a resident of Thomas for 55 years.

Nick DiMaio, an Italian immigrant, arrived in Thomas at the age of 17 from Campodipietra, a town in the Abruzzi region of Italy. DiMaio first found work at the coke ovens, then delivered groceries around town. He operated his confectionery shop on Front Street for 41 years, offering delightful treats to his customers. Many fondly recall the fragrance of roasted peanuts drawn hot from Nick's gas-fired oven and offered generously to his customers.

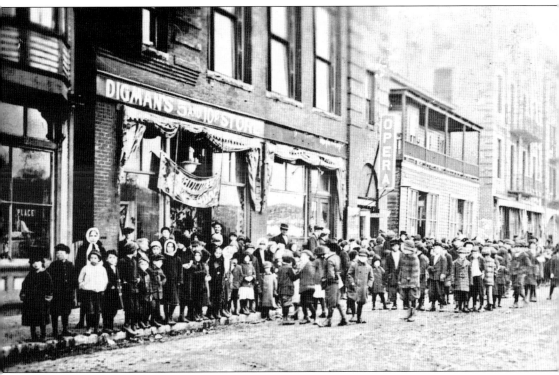

Throngs of children wait outside for the next show at the Opera House in Thomas. Hiram Cottrill's Opera House was built by Holcomb and Lafferty of Clarksburg in 1902. In its heyday, it featured a wide variety of entertainment, from plays and stage shows to vaudeville, minstrel shows, and silent movies. An elegant saloon on the Opera House's first floor created a sometimes raucous atmosphere not conducive to gentle entertainment. However, in 1912, manager C. B. Pascoe advertised to "send the children, they will be cared for." Later generations knew the building as the Sutton Theater when live performances gave way to more profitable talking picture shows. The plush interior, comfortable seating, and excellent acoustics made the Sutton Theater the place to be and be seen. The theater was routinely packed on Saturday with people arriving in Thomas by train and car from surrounding communities.

A business partnership was formed by brothers Charles and Peter Milkint in 1920. Both brothers had been born in Lithuania in the late 1800s. The construction of their garage was completed in 1921, and they first sold REO cars and speed wagon trucks. The Milkints followed the latest

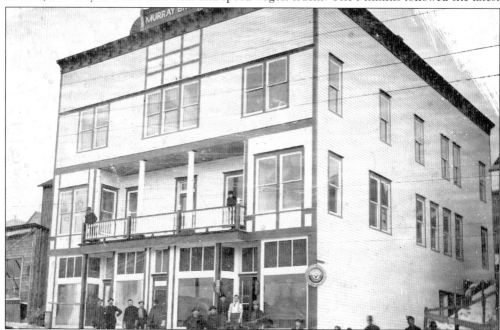

Rooms at the new Mountain View Hotel on Spruce Street in Thomas rented for $2 a day in 1906. Proprietor J. B. Murray advertised "newly furnished" rooms that were "first class in all its appointments." He promised traveling salesmen "a good sample room" and a "first class bar." Construction was begun in 1901 by a company from Fairmont, West Virginia, and completed in 1903 by A. N. Clower, a subcontractor from Keyser, West Virginia. (Courtesy Jane Barb.)

52

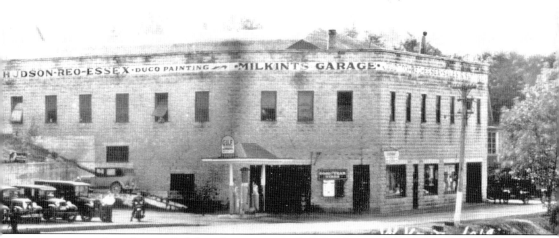

automotive trends and expanded their business to include Hudson and Essex cars, later adding DeSoto and Plymouth. The partnership dissolved in 1945, allowing Pete Milkint time to devote to Silver Lake, one of the area's first planned tourist developments in nearby Preston County.

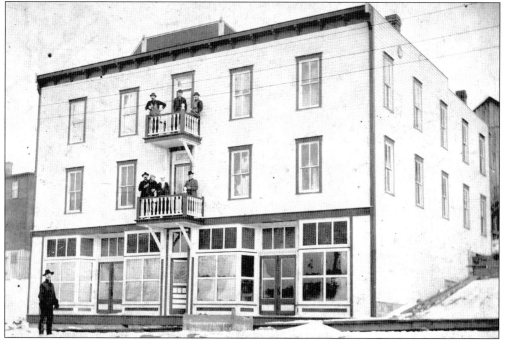

Construction flourished after a fire in 1901 consumed much of the downtown commercial and residential sections of Thomas. One of the buildings erected after the fire still stands today on Spruce Street. Known as the Tap Room, it was begun by Mike Brock and was completed by A. N. Clower, a sub-contractor, in December 1903. (Courtesy Jane Barb.)

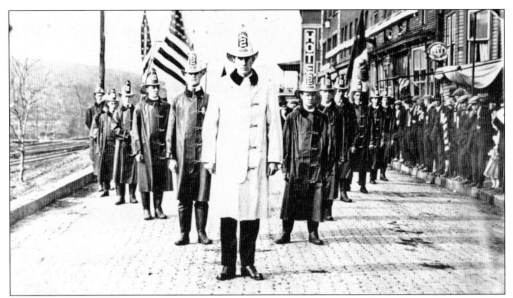

Fire chief Slim Fansler with his crew turn out in full firefighting gear on Front Street. In the middle of the night in November 12, 1901, a fire broke out in downtown Thomas. Most of the buildings, which were constructed of wood, were quickly consumed by the fire. Eighty-three buildings were destroyed. The town was ill-equipped for fighting fires. This devastating event led the town to form a modern and well-equipped fire department. (Courtesy Wilburn Fansler.)

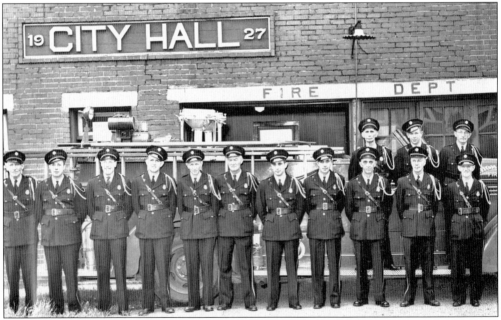

The Thomas Volunteer Fire Department is shown in 1952 at the annual homecoming in Thomas. The festivities of the day honored D. E. Cuppett, a local attorney and politician. Shown are, from left to right, (front row) Emmett Barnes, Arthur Quattro, William Jones, Junior Schoonover, Harley Kight, Bert Pase, Junior DePollo, Elmer Cross, Willis Carr, Herbert Pase, and Bernard Wenck; (back row) W. G. Helmick, Arthur Kight, and Ray Jones. (Courtesy Tucker County Historical Society.)

The queen and her court pose for the photographer under a canopy of mid-summer rhododendron. The picture from the early 1950s was taken during Thomas's homecoming celebration. This annual celebration, a predecessor to the modern-day Mountaineer Days, took place over the Fourth of July holidays. As it does today, it offered an opportunity for families to celebrate the holidays together.

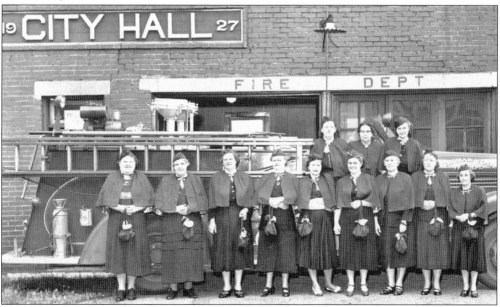

Here is the Ladies' Auxiliary of Thomas Volunteer Fire Department at the 1952 annual homecoming in Thomas. Shown are, from left to right, (front row) Mura Cooper, Viola Martin, Anna Wenck, ? Dawson, Effie Bland, Evelyn Shrader, Ella Harris, ? Cross, and Dorothy Cangley; (back row) Evelyn Jones, Nellie Huffman, and Erma Pase. (Courtesy Tucker County Historical Society.)

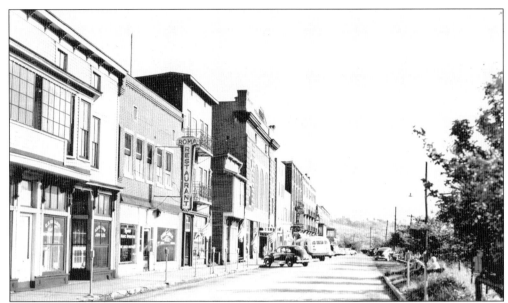

The business district in Thomas is contained on two lower streets, Front and Spruce. In this photo dating from the 1930s, the scene on Front Street looks south. Some of the businesses at the time included, from left to right, O. S. Collins, sporting goods and jeweler; Roma Restaurant and Lunch, offering fine baked pastries, beer, soft drinks, and dancing; Patsy Santangelo, shoemaker and repair; Fansler's barber shop; Sutton Theater; and S. DiBacco & Sons. (Courtesy David F. Strahin.)

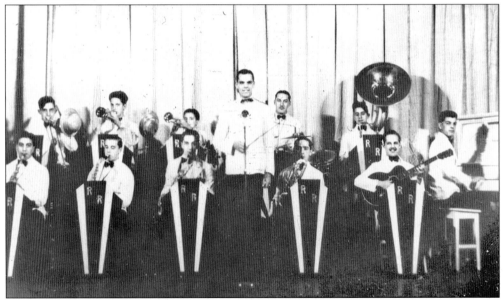

Reed Raines and his orchestra appear at the Hotel Imperial in Thomas, West Virginia, in the early 1940s. Pictured from left to right are (front row) Carmen Monda, Carmen DiBacco, Paul Monda, Reed Raines, Orlando Massi, Charles Sutton, and Jack Mosser (piano); (back row) Dave Walters, Kenneth DePollo, Ralph Santangelo, Alex Parks, and Ugo Massi. Some members of Raines's orchestra went on to form the popular local group called the MidNighters soon after World War II.

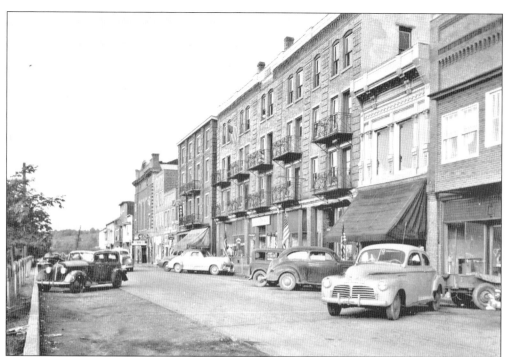

Looking north on Front Street, some of the businesses that were operating in the 1930s are pictured. From left to right, they are Sutton Theater; S. DiBacco & Sons, clothing, hardware, groceries, and the Varsity Restaurant; bowling alley and pool room; Nick Dimaio's candy shop; and The Princess Shoppe, women's clothing. (Courtesy David F. Strahin.)

Pasquale "Patsy" Santangelo moved to Thomas in 1932 and became a constant in a community where musical training was encouraged and appreciated. Scores of students found their way to Patsy's music lessons, learning under the stern taskmaster and taking away an appreciation of music from the experience. Patsy's son Ralph (pictured here) was one of those talented students who excelled in technique and showmanship. Ralph studied music in California, formed a studio band, and made a living as a professional musician in Hollywood.

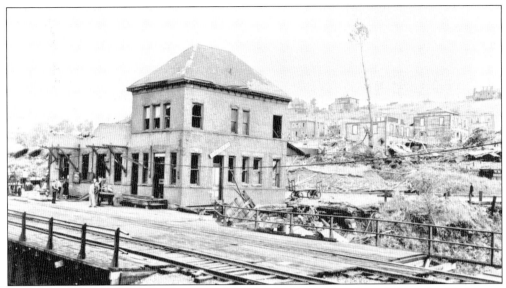

Thomas is situated on a high plateau, and strong winds are often funneled up the Blackwater Canyon. During a nearly 30-year period from 1925 to 1954, three tornadoes struck the area. In 1925, winds collapsed a tipple at Pierce, killing three boys. On Friday, June 23, 1944, a second tornado struck at 11 p.m. in Thomas, practically destroying the railway station.

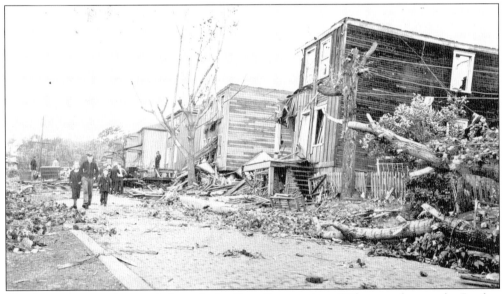

The destructive winds moved through the Tony Row section of Thomas, then to the Bunker Hill area, and then headed southeast toward Canaan Valley. In its path, the tornado left 26 homes completely destroyed and 20 others severely damaged. Three persons were killed and several injured.

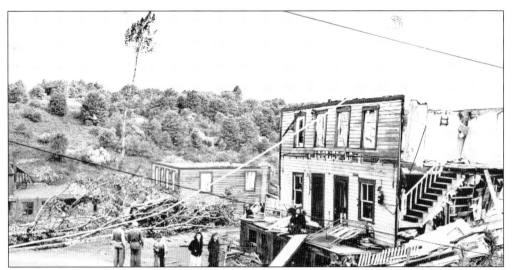

The tornado took a southeasterly path through the Davis cemetery and into Canaan Valley. It knocked down buildings, trees, and tombstones as it went. In Canaan Valley, five soldiers training for Alpine maneuvers were injured, with their food, clothing, tents, and equipment scattered over the countryside.

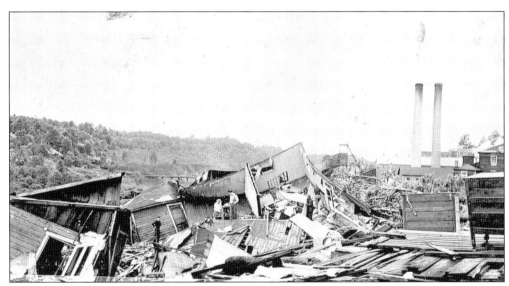

Medical, military, fire department, and citizen volunteers offered assistance to the injured and displaced of the 1944 tornado. Ten years later, tragedy struck again in another part of Thomas. The tornado struck on the night of July 14, 1954, and caused damage on Second and Third Streets, closer to the town center. Damage from this event was estimated to be over $100,000.

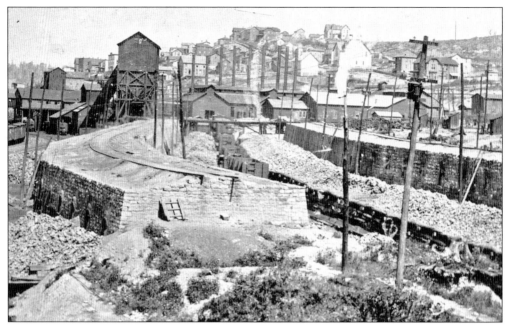

Early in its history, Thomas and the surrounding area were found to possess exceptionally rich reserves of coal. In 1887, the Davis Coal & Coke Company constructed two experimental coke ovens to test the quality of the coal. Coke was in high demand for making steel and iron. By 1897, the company had 370 coke ovens in operation at Thomas and Coketon, supplying coke to steel producing areas like Pittsburgh.

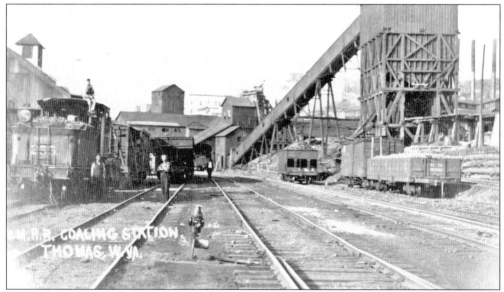

The Western Maryland Railway line ran directly through the town of Thomas, making the loading of coal from nearby mines relatively easy. Construction of the tipple near Mine No. 23's entrance in Thomas further facilitated the process. Coal from Thomas helped provide the fuel that drove industrial development in the United States. For most of its existence, Davis Coal & Coke Company averaged a yearly production of 1.5 million tons of coal from its mines. (Courtesy Western Maryland Railway Historical Society.)

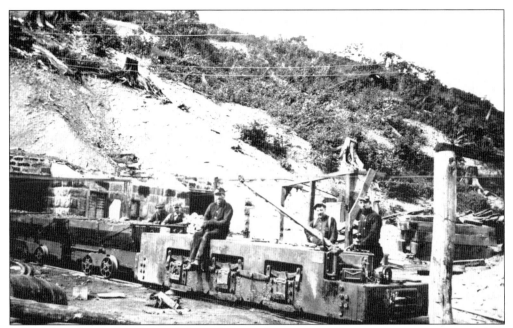

Miners bring loads of coal out of the underground mine in small mine cars, or lorries, propelled by an electric engine (far left). The lorries were brought in close proximity to empty railroad cars where their contents were "tipped." Prior to mines being electrified, much of the power needed to bring loaded cars of coal to the surface was provided by mules, ponies, or oxen. (Courtesy West Virginia and Regional History Collection, WVU Libraries.)

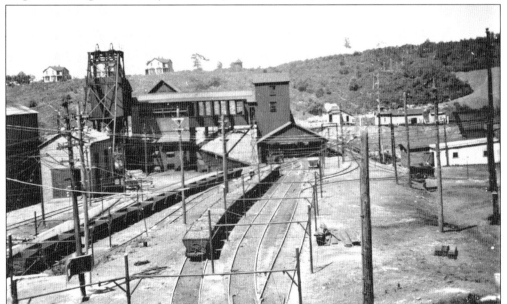

Looking west toward Railroad Hill, this picture was taken from near the opening of Mine No. 23 in Thomas. Lorries wait for their loads to be dumped at the tipple, and empties will again be taken into the mine to be filled. Many of the same structures at the Thomas industrial complex can also be seen in the photograph on the bottom of page 60. (Courtesy West Virginia and Regional History Collection, WVU Libraries.)

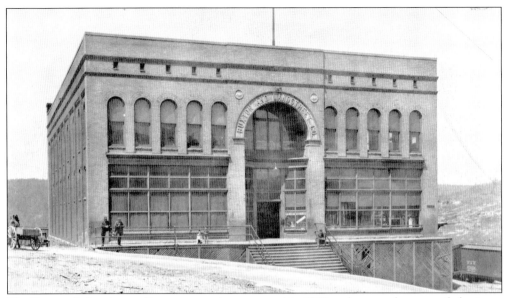

The Buxton & Landstreet Company was incorporated in 1889 to do general mercantile business in Davis Coal & Coke Company towns. The building housing the Thomas branch of the B&L Company store opened in 1900 and operated until the early 1950s, when mining experienced a downturn in Thomas. Many of the architectural details of this impressive building have survived to this day. (Courtesy West Virginia and Regional History Collection, WVU Libraries.)

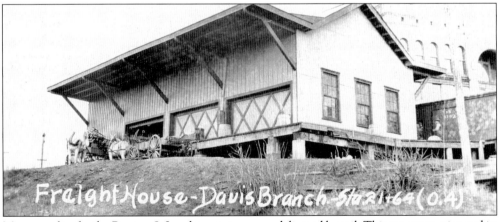

Many supplies for the Buxton & Landstreet store were delivered by rail. This structure, pictured in 1917, served as the freight depot. It stood downhill from the B&L Building on the Davis Branch of the West Virginia Central & Pittsburg Railroad. Completed in 1899, it received merchandise for the B&L Store: "Everything for the table, everything for the home, and everything for everybody." (Courtesy Western Maryland Railway Historical Society.)

The Davis Coal & Coke Company administration building in Thomas was constructed in 1900. It was the center of field operations for the company and its successors until 1950. The two-story brick structure played a central role in DC&C miners' lives and those of their families. Miners were hired, paid, and fired here. The building also housed the engineering department, where the area's numerous mines were planned, designed, and managed. (Courtesy Western Maryland Railway Historical Society.)

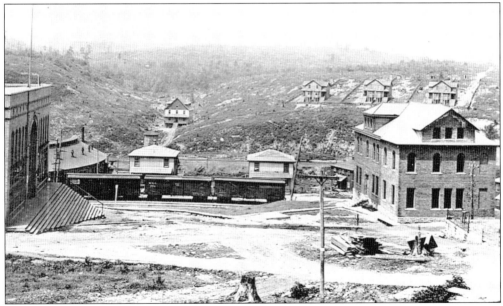

This picture shows the proximity of the administration building, the company store, and the railroad. Every Davis Coal & Coke Company town had a store operated under the name Buxton & Landstreet Company and owned by DC&C. Stores usually operated outside of city boundaries. The B&L store sat 100 feet south of the DC&C office building, just outside of Thomas city limits, in the unincorporated suburb of Coketon.

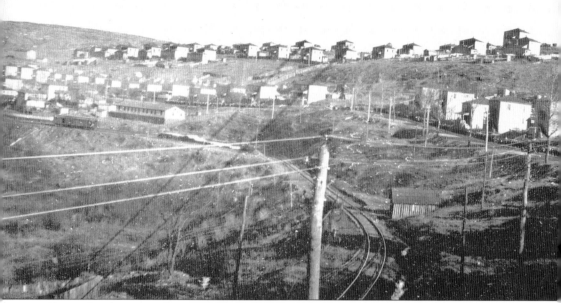

Rows of coal company houses are shown here on Tony Row. Although officially designated as East Avenue, the names of many streets in Thomas are interchangeable and local rules of naming often apply. The local name "Tony Row" originated from the fact that so many Italian workers (many with the first name of Anthony or Tony) occupied the homes on this street. In the later part of the 19th century and early 20th century, Thomas experienced a great tide of immigration from southern Europe. Italians made up a large part of this wave, and many families in Thomas can trace their ancestry to that country. Workers came to build the railroad, stoke the coke ovens, and work as merchants and miners. Families with names like Balassone, Colabrese, DeCicco, DiBacco, DePollo, Gennantonio, Grecco, Lambruno, Massi, Monda, Pinto, and Quattro came to Thomas and made their mark on the landscape of the town. (Courtesy West Virginia and Regional History Collection, WVU Libraries.)

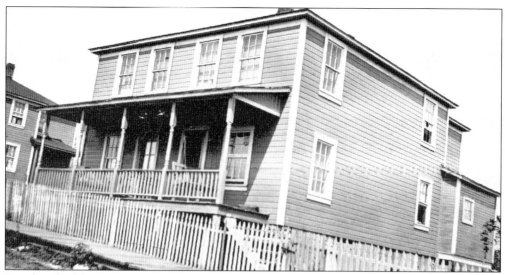

Four hundred families lived in Davis Coal & Coke Company housing in 1906. Rent was taken directly from salaries. Compared to other coal company housing, these homes could be described as "adequate." Typical workers' houses were duplexes, with two families occupying a single dwelling. Small plots of land allowed many miners to maximize their budgets by cultivating gardens, planting fruit trees, and raising livestock. (Courtesy West Virginia and Regional History Collection, WVU Libraries.)

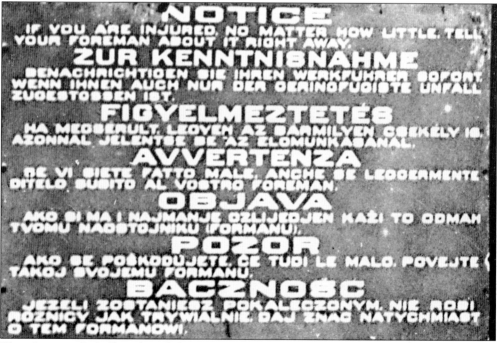

This close-up of a bulletin board shows a safety message in seven different languages, reflecting the diversity of mine workers. At one time, 18 different nationalities were represented in Thomas. Wladyslaw Dackiewicz came to Thomas in 1903 and put his extensive linguistic skills to work as an interpreter for the coal company. Dackiewicz could speak, read, and write eight different languages. (Courtesy West Virginia and Regional History Collection, WVU Libraries.)

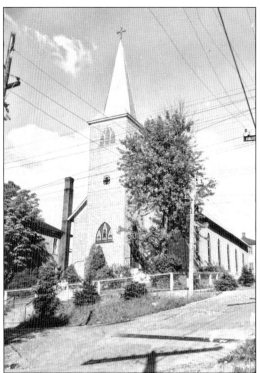

The Catholic Church in Thomas had its beginnings in 1892. A growing wave of new immigrants from Italy, Poland, Slovenia, Croatia, and Russia joined Irish and French-Canadians who had arrived earlier in Tucker County. Soon, the Saint Thomas Parish was organized, and a church was completed in 1897. It fell victim to the fire of 1901 (see page 54), but the community rallied to rebuild the new structure, pictured here. (Courtesy David F. Strahin.)

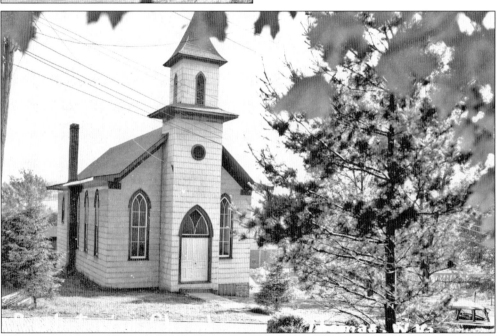

The congregation of the Thomas Presbyterian Church first held services in 1900 at town hall. Worship services continued to be held there while the church structure was being built. In spring 1901, the first services were held in the new church, located at the corner of First and Brown Streets. Rev. R. W. Carter, pastor of the Davis Presbyterian Church, organized the church in Thomas. (Courtesy David F. Strahin.)

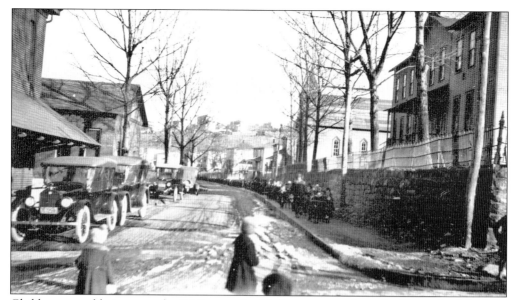

Children assemble to enter the B&L store for Christmas treats from the Davis Coal & Coke Company. Pictured in the foreground (right) is the Central School Building. The school had grown from a small two-room structure built in 1890 to six rooms with the addition of two wings. Central School also housed the first church services for many different denominations in town. (Courtesy West Virginia and Regional History Collection, WVU Libraries.)

One of the first sermons preached in the town of Thomas was delivered from the platform of the railroad depot by a Methodist Episcopal minister. The Methodist Episcopal Church of Thomas was constructed in 1903 at a cost of more than $4,000 and was dedicated on June 21 of that year by Dr. C. W. Smith of Pittsburgh. Land upon which the Methodist parsonage and church were built was donated by Henry G. Davis.

NOTICE TO MEN SEEKING EMPLOYMENT

UNLESS YOU ARE WILLING TO BE CAREFUL TO AVOID INJURY TO YOURSELF AND FELLOW WORKMAN. DO NOT ASK FOR EMPLOYMENT. WE DO NOT WANT CARELESS MEN IN OUR EMPLOY.

In 1886, John Henry Pase was the first miner to die in a Thomas mine. Although DC&C had a relatively good reputation for mine safety compared to other mining communities in West Virginia, catastrophic events still occurred. On the morning of February 4, 1907, an explosion occurred at Mine No. 25 that killed 25 men. The cause of the explosion was attributed to a miner's lamp contacting a gas-filled chamber. (Courtesy West Virginia and Regional History Collection, WVU Libraries.)

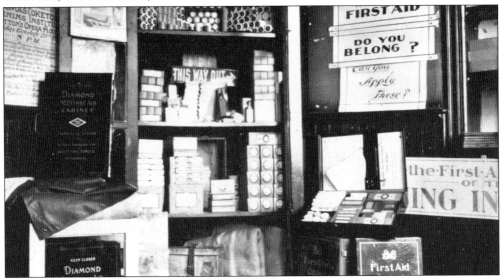

Davis Coal & Coke Company encouraged safety and basic first-aid training. A poster advertising a general meeting of the Thomas-Coketon Mining Institute hangs on the wall beside a display of items essential to miner safety. At the time of this photo (c. 1918), regular training sessions were held in towns where DC&C operated mines. Skills of teams and individuals were tested with competitions held between towns. (Courtesy West Virginia and Regional History Collection, WVU Libraries.)

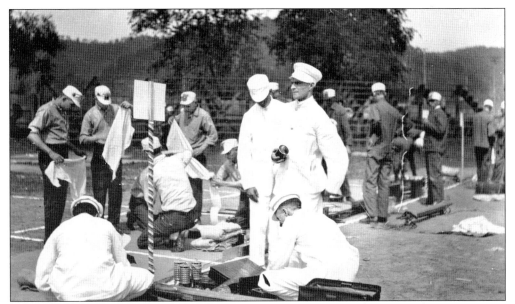

Practicing "Safety First," this team applies what it knows to several real-life mining disaster scenarios. One of the problems presented in this full-team competition at Thomas in 1918 could have been reality to the competing teams: "Man found under fall of coal with compound fracture of left leg six inches below knee, broken 8th rib on right side, cut on left side of face bleeding in spurts. Treat case and three (3) men carry patient 20 feet where passage is too narrow to permit a stretcher." Teams were allowed 15 minutes to deal with this scenario. (Courtesy West Virginia and Regional History Collection, WVU Libraries.)

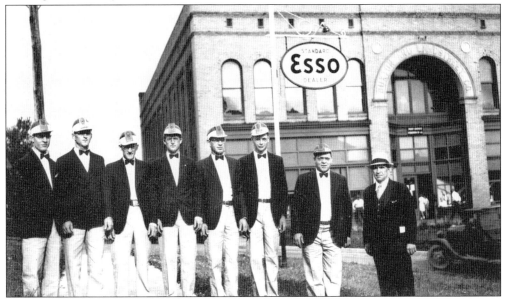

Pictured here in front of the Buxton & Landstreet store in Coketon is a mine safety team. Team No. 5 from Kempton won the competition in 1918. That team was made up of Matthew A. Stewart, superintendent; Roy Smith, captain; John B. Watkins, captain; Henry Larsen; George Larsen; Henry Fulmer; A. N. Curry; and Sam Wallwork, patient. (Courtesy West Virginia and Regional History Collection, WVU Libraries.)

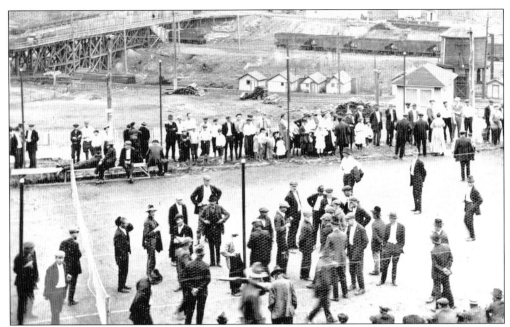

Thomas had its share of strife from attempts to unionize mines. On the night of June 27, 1922, National Guardsmen were summoned to Coketon to put down the possibility of a general uprising among striking miners. Ninety striking miners were detained and placed under guard at a wire-enclosed tennis court in Thomas before being loaded on a train to Parsons, where they were to be formally charged. (Courtesy Western Maryland Railway Historical Society.)

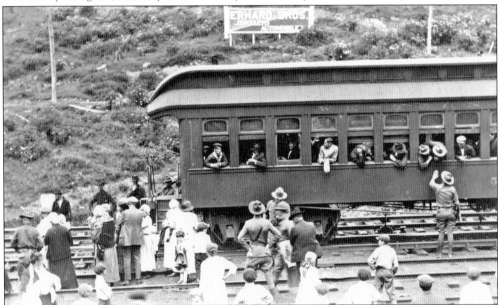

The passenger coach transporting the 90 striking miners wrecked on June 28, 1922, about a mile from Hendricks. Many of the miners and guardsmen were seriously injured, and one miner was killed. The accident was attributed to a broken wheel on an old coach that had been attached to the train in Thomas. Whether this incident was accidental or an act of sabotage is still a point of discussion. (Courtesy Western Maryland Railway Historical Society.)

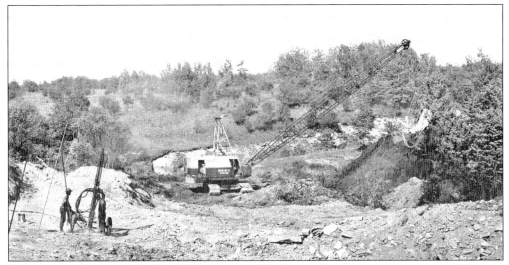

A drag line is being used by Dodd & Archer at Blackwater Manor operations between Thomas and Davis in June 1947. By 1946, Davis Coal & Coke Company had closed its underground mines in neighboring Mineral, Grant, and Randolph Counties, and operated only in Tucker County. Strip mining began that same year. Thereafter, production from strip mining quickly outpaced underground mining. (Courtesy USDA Forest Service, Monongahela National Forest.)

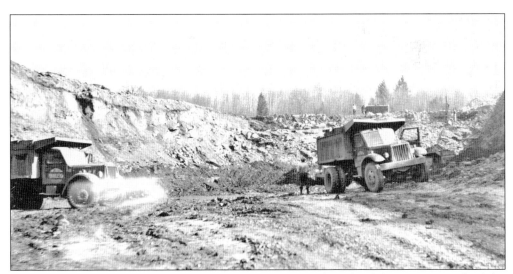

Strip mining between Davis and Thomas destroyed the rail grade of the Davis Branch of the West Virginia Central & Pittsburgh, which was the original grade into Davis. Rail traffic into Davis had ended in 1942, and the rails were removed at that time. The product of this surface mine was transported to Thomas by a relocated line called the Francis Branch. This line was abandoned in the late 1970s.

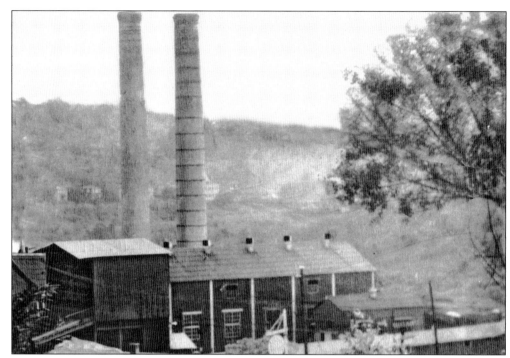

Electricity from Davis Coal & Coke Company's power plant lit street lights and many homes in Thomas beginning in the early 1900s. As part of upgrades to their existing system, the company completed a 160-foot-tall concrete tower in June 1910. Reported to be one of the tallest in the state at the time, it was part of an improved network begun in the fall of 1910 to provide electricity to the mines around Thomas.

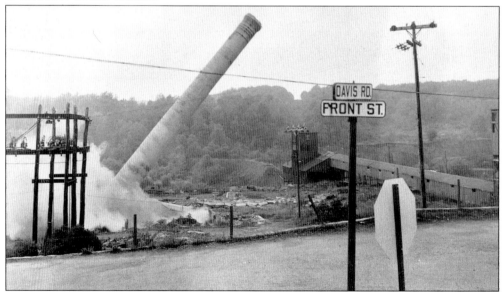

The tower of the Davis Coal & Coke Company power plant is demolished in August 1959. This single act marked the end of a disappointing decade of economic decline in Thomas. With it also came the demise of Davis Coal & Coke Company, which had dominated the local landscape for 75 years. (Courtesy Tucker County Historical Society.)

Five

AT THE FOREST'S EDGE
Davis

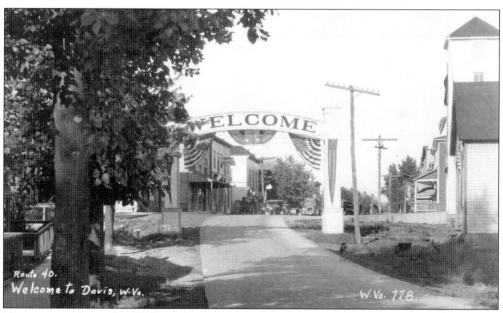

Visitors are welcomed to William Avenue in Davis sometime in the 1920s. During the 20 years following the Civil War, Henry Gassaway Davis and his brothers, William and Thomas, purchased thousands of acres of land in Tucker County. Their railroad reached the Davis family's namesake community in November 1884. At this time, stumps left behind from the cutting of timber for the town site cluttered the landscape. The town earned the nickname "Stumptown," reportedly because one could make their way across town by hopping from one stump to the other. Davis was incorporated in 1889 when the population was 909. In 10 short years, the population had swollen to 2,319. (Courtesy David F. Strahin.)

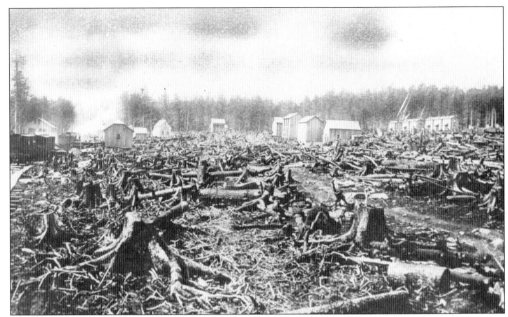

The site of Davis (shown here in 1883) had stood in a forest of huge trees. One newspaper reporter observed that "the town had a rough and unattractive appearance." Charles Ridgely was hired to remove stumps to improve the appearance of the town. He was to be paid 35¢ per stump but soon asked to be released from his contract. Each stump that Ridgely cut cost him a whopping 75¢ to remove. (Courtesy Tucker County Historical Society.)

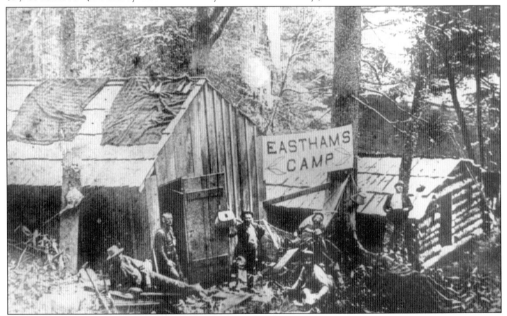

Pictured here is Robert Eastham's camp located on the Blackwater River near Davis. Robert Eastham had come to Canaan Valley in 1876 to farm after serving in the Confederate army during the Civil War. In 1883, he received word that the railroad would soon reach the area. Eastham worked to clear the town site, soon opened a store, and played a major role in the logging history of the area. (Courtesy Virginia Cooper Parsons.)

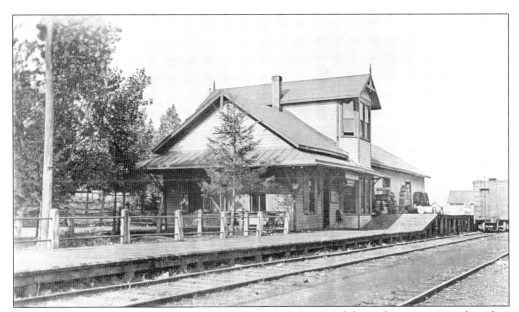

Passenger train service started in Davis in June 1885. A train delivered passengers and mail in Davis, then boarded outbound passengers and freight cars destined for near and far. Within a five-minute walk of the depot were lumber mills, hotels, restaurants, banks, retail operations, boarding houses, and hotels. At one time, a miniature golf course operated—just one of many services and entertainment offered in Davis.

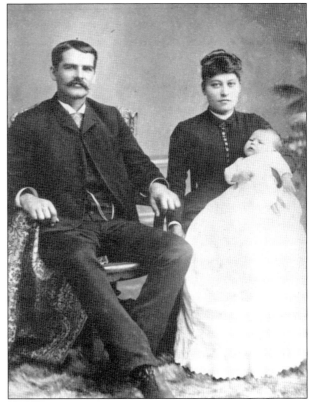

Pictured in 1887 are John and Minnie (LaRue) Raese with their firstborn son, Cleon. John Raese was 28 in 1885 when he brought his team of horses to Davis to help clear the town site. He and Minnie wed in 1886. Raese grew a business built around his beloved horses, delivering household goods, coal, lumber, and stock feed with his teams. In 1892, he began a grocery business, which remained in operation for decades. (Courtesy Walter Raese.)

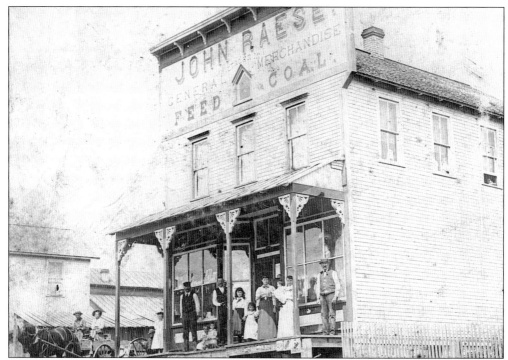

In 1892, John Raese became a partner in a family grocery business at the corner of Thomas Avenue and Seventh Street in Davis. Raese General Mercantile sold shoes and dry goods; groceries and cooking utensils; potatoes and vegetables; and flour by the sack. Several of John and Minnie Raese's 11 children followed their parents into retail, establishing successful businesses in both Davis and Morgantown. (Courtesy Walter Raese.)

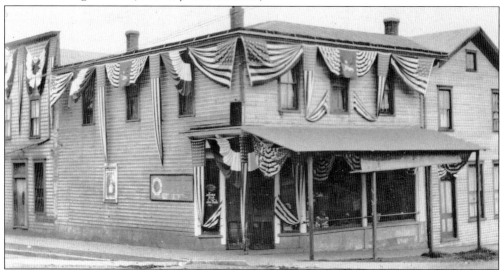

Cleon Raese was the oldest of John and Minnie Raese's children. He operated a clothing store, meat market, and grocery store in Davis. His store on Thomas Avenue in Davis is pictured here. Emulating his parents by participating in church and civic activities, Raese was an active member of the Presbyterian Church, served as councilman and mayor of Davis, and was elected to the West Virginia State Legislature. (Courtesy Frances Tekavec.)

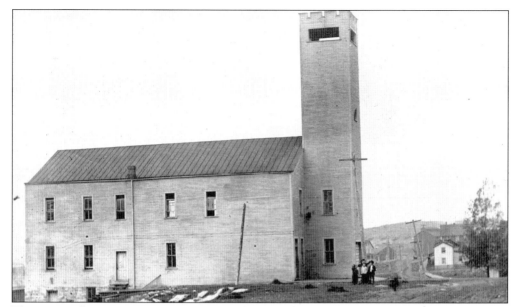

The center of community activities in Davis for over 100 years, this structure was erected in 1894. Dances, concerts, political meetings, and other festivities took place under its roof. At different times, it has been called the Hose House, Fireman's Hall, City Hall, and Town Hall. The height of the tower was lowered in 1909 because it started to lean due to the weight of the bell in its bell tower. (Courtesy Dorothy Thompson.)

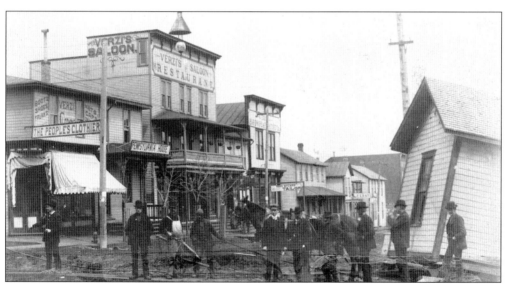

This photograph provides evidence of the first "mobile home" being delivered in Davis. Some businesses on William Avenue were, from left to right, Verzi's Clothing; The Pennsylvania House; Verzi's Saloon and Restaurant; Davis Hardware and Furniture; Theodore Stumpf, tailor; and J. Lantz, shoe maker. Most buildings were owned by Austrian immigrant Joseph Verzi and his extended family of siblings, in-laws, and children. Verzi came to Davis in 1890 and worked as a tailor. (Courtesy Dorothy Thompson.)

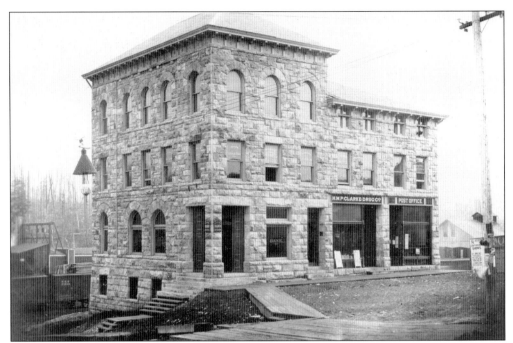

The three-story National Bank of Davis Building was constructed of native stone in 1892. The National Bank of Davis is the oldest bank and business establishment in Tucker County. Thomas Beall Davis was the bank's first president. At the time of this photo (c. 1905), the building also housed Davis Post Office, HMP Clarke Drug Company, C. O. Strieby Law Office, Davis Electric Company, and Marshall Coal & Lumber. (Courtesy Western Maryland Railway Historical Society.)

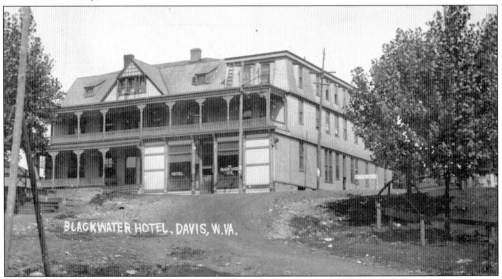

The Blackwater Hotel in Davis was built in 1886 by the West Virginia Central & Pittsburg Railway Company. For many years, it was the outstanding hotel along the line from Cumberland to Elkins and had a reputation for providing spectacular food and service. It boasted 40 rooms, a barbershop, and a barroom. When the railroad discontinued service in 1942, the building was dismantled by the owners, Mr. and Mrs. William Kramer. (Courtesy Dorothy Thompson.)

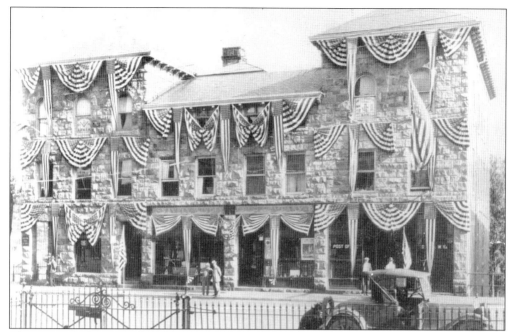

The Davis Bank Building was remodeled in 1898 and the west wing, which now houses the Davis Post Office, was added in 1915. This picture, taken in the 1920s, shows the Grand Lady dressed up for a patriotic celebration. At the time of this photograph, some of the other tenants were the Fairfax Lodge, Green Mountain Lodge No. 42 of Knights of Pythias, and Snavely-Windle Drug Company. (Courtesy Frances Tekavec.)

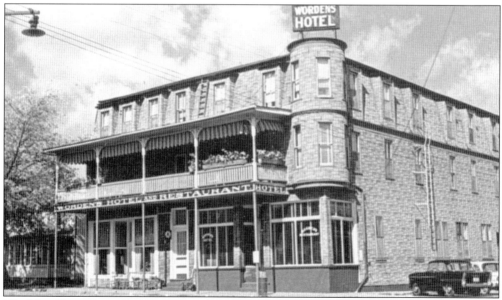

The New Howard Hotel was completed in 1898 and stood at the corner of Thomas Avenue and Third Street in Davis. In 1917, Harry Worden purchased and remodeled the building. Then, in 1927, the hotel and restaurant opened under the name Worden's Hotel. The hotel, operated by Belmont and Katheryn (Worden) Cleaver, accommodated hunters, anglers, spelunkers, soldiers, hikers, and skiers. Katheryn Cleaver's home-cooking attracted locals and out-of-towners alike.

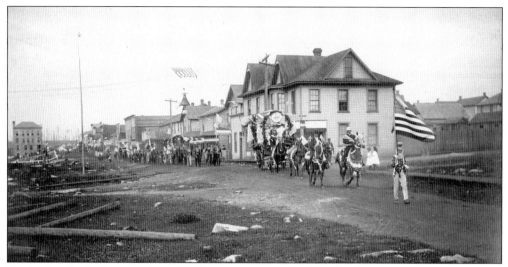

Uncle Sam leads the way down William Avenue in the Fourth of July parade in Davis. The picture, taken in 1898, shows carriages, horses, and people dressed up for the festivities. The three-story stone building in the distant background is the National Bank of Davis. (Courtesy Dorothy Thompson.)

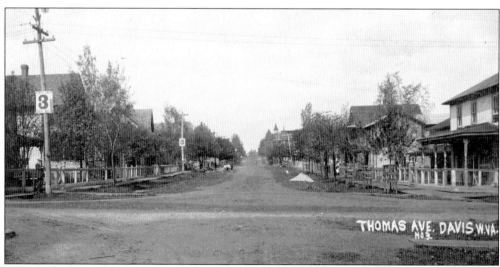

Thomas Avenue in Davis, c. 1904, shows a tidy street with young trees carefully planted on lawns. This picture was taken at the corner of Second Street. A boardwalk runs the entire length of the street. Just 20 years before, men and horses worked to remove virgin timber to make way for the future site of the town of Davis. Sturdy houses sprang up around the central industrial focus of the town, a sawmill on the banks of the Blackwater River. (Courtesy Dorothy Thompson.)

In this photograph, the Coffman-Fisher department store (right foreground), Meyer House (right background), and Worden's Hotel (left) appear on Thomas Avenue in the 1920s. Eugene Coffman came to Davis in 1894 and opened a small novelty store. As his business grew, he rented a room in a meat market from Mr. ? Shobe, became owner of this building, and later opened the Coffman-Fisher Department Store in Davis. Coffman-Fisher Department Stores developed into a chain of 22 stores, which operated from 1923 to 1938. Belmont Cleaver, auditor for the chain, purchased the Davis store, naming it Belmont's. Developing his own product line in response to the community's needs, Cleaver not only sold clothing, variety goods, and hunting and fishing licenses, but also offered ski rentals to a new industry developing in Canaan Valley. (Courtesy Frances Tekavec.)

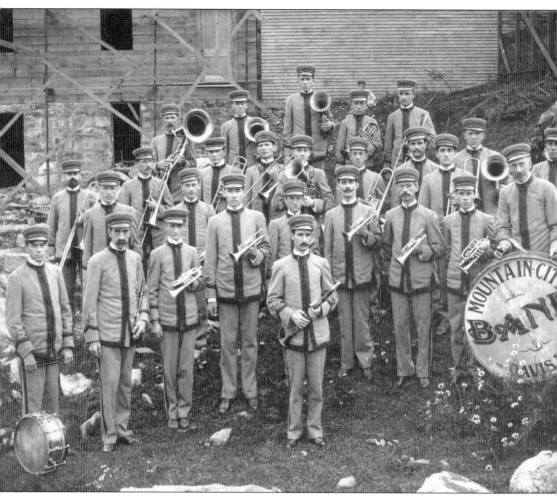

The Mountain City Band of Davis was a 32-piece band that gave concerts and played in parades, at political meetings, and for celebrations of all occasions. It was organized in 1905 and incorporated in 1906. The band poses in their newly purchased uniforms in 1907. Pictured here are (not in order) director Herbert L. Blaker, Clarence Q. Arbogast, Adam Stein, J. W. Kogleshatz, R. C. Weidemire, F. N. Morin, Lucien H. Mott, John Johnson, Ray Dawson, Frank E. Heiskell, John Rauschenberger, Sherman Iden, Harry Weaver, Dr. N. McK. Wilson, Theo Stumpf, Charles G. Stater, Illario Lacconno, Harry Buckley, Robert C. McKelvey, Neil C. Heiskell, Charles Amlaw, Benson Unger, and Edwin Morin. (Courtesy West Virginia and Regional History Collection, WVU Libraries.)

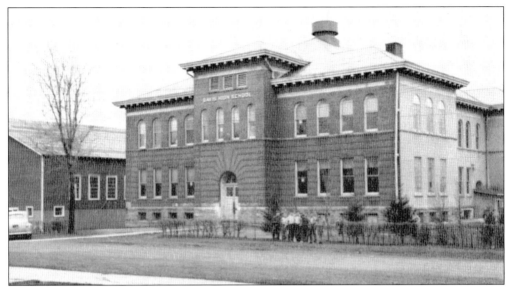

Davis High School became the first high school in Tucker County in 1903. Located on the hill overlooking Davis, the school graduated outstanding students and athletes. In 1955, Davis and Thomas High Schools were consolidated. Former rivals came together in Davis under one roof. The first senior class of Mountaineer Senior High School graduated in 1956. (Courtesy Frances Tekavec.)

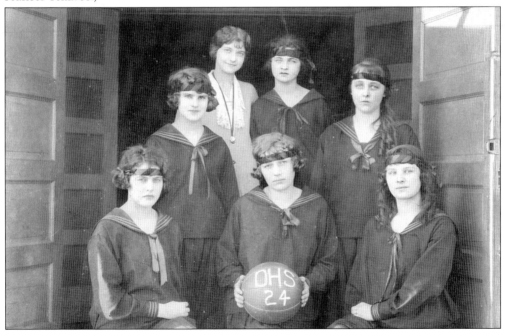

Members of the stylish 1924 Davis High School girls' basketball team pose in the doorway of gymnasium. Suited up and ready for action are, from left to right, (front row) Virginia Harper, Catherine Hottle, and Mae Colaus; (middle row) Margaret Wilfong and Rosa Lee Batt; (back row) coach Viola Wick and Irene Worden. The Davis gymnasium was built in 1922 and was the first and only public school gymnasium in Tucker County for many years. (Courtesy Edward R. Kepner.)

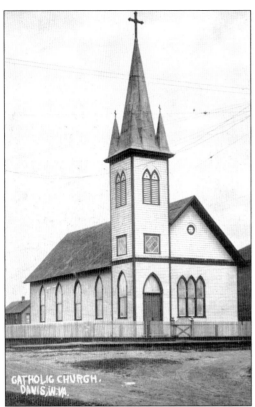

In 1893, the first Catholic services in Davis were held in the engine house of the West Virginia Central & Pittsburg Railway Company. Soon, a building lot was obtained at the corner of Kent Avenue and Fifth Street. Much of the work of building the church was done by Davis parishioners. St. Veronica's Catholic Church in Davis was dedicated in 1897 by Bishop Patrick Donahue of Wheeling. (Courtesy Dorothy Thompson.)

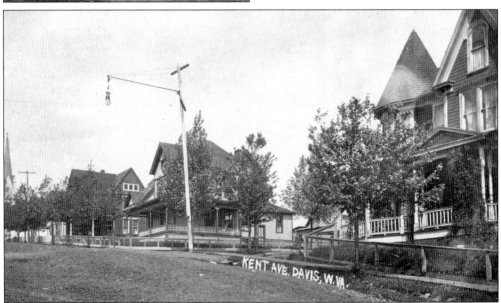

The Charles Ellsworth Smith home (center) is pictured at the corner of Kent Avenue and Fourth Street in Davis. Smith played a role in bringing electricity to Davis in 1893. Smith, along with Thomas B. Davis, Harry G. Buxton, F. S. Landstreet, and Herman Meyer, started the Davis Electric Light Company. A dam was constructed across Beaver Creek, and electricity was generated by water power. (Courtesy Dorothy Thompson.)

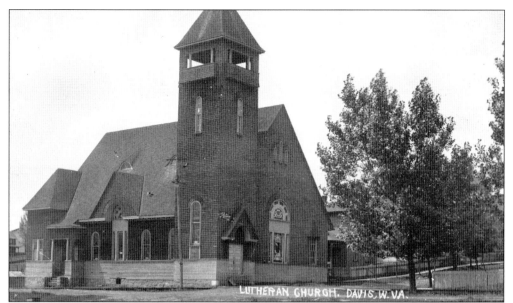

Dedicated in 1894, St. John's Lutheran Church still serves the community of Davis today. In 1893, construction began, the congregation was formed, and J. F. W. Kitzmeyer was hired as the church's first pastor. Until the structure was completed in 1894, services were held at various locations around Davis. Reverend Kitzmeyer conducted catechism classes, followed by a Bible story and one of Grimm's or Anderson's fairy stories, popular in the 1890s. (Courtesy Dorothy Thompson.)

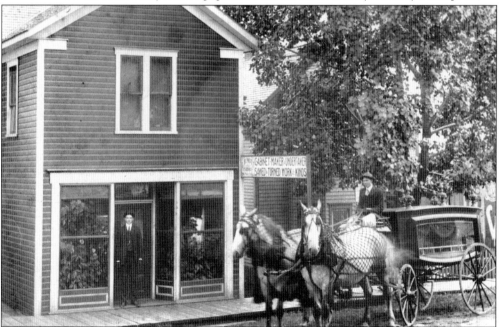

Lucien H. Mott (pictured in 1903) was the undertaker in Davis from 1903 until 1948. Mott advertised his diverse talents as "cabinet maker-undertaker-sawed and turned work of all kinds" on windows of his business. Mott's skills in working wood probably came in handy. In those days, coffins were shipped from factories untrimmed, then decorative pieces were applied at the place of business. (Courtesy West Virginia and Regional History Collection, WVU Libraries.)

In the mid-1890s, L. S. Tewell built an Opera House in Davis where minstrel and vaudeville shows were performed by traveling troupes. This building stood on the corner of Kent Avenue and Second Street and could accomodate up to 1,200 people. The Liberty Theater on Thomas Avenue (pictured above) later joined the ranks of establishments that entertained generations of Davis residents and served as a location for the town's social gatherings. (Courtesy Frances Tekavec.)

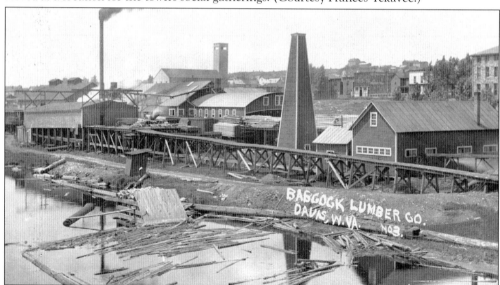

The Babcock Lumber and Boom Company began operating in Davis in 1907. During the 17 years that the Babcock mill was in operation, it sustained one continuous, nine-year stretch without an idle day. The plant operated two sawmills in Davis, one for hardwoods and one for softwoods. When the Babcock mill closed, 38 years of large scale lumbering ended in Davis. (Courtesy Dorothy Thompson.)

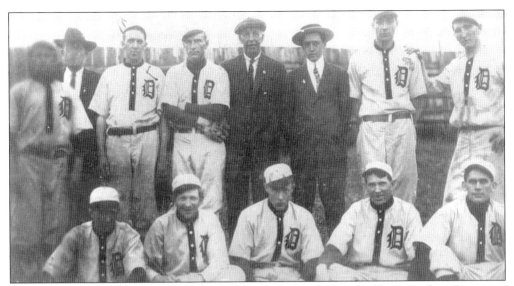

This photograph was taken around 1911 of the Davis baseball team. The team from Davis was always a formidable opponent. Members of the team are, from left to right, (front row) two identified men, Malone Gainer, Frank Mustard, and Bob Calvery; (back row) unidentified, Dr. ? Burley, Slim Tanner, unidentified, Aldine Poling, Rugby Poling, Pat Clark, and Jim Buckley. (Courtesy Frances Tekavec.)

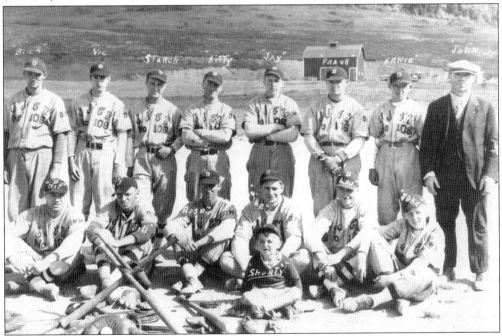

The South Slovenia Catholic Union Lodge 106 Team takes the field. Pictured are, from left to right, (front row) mascot Frankie "Shorty" Porak; (middle row) John "Nip" Kosanic, William "Bill" Kosanic, Frank "Rose" Kosanic, Michael "Mike" Kosanic, Louis "Lou" Honigman, and Joe "Jake" Kerzic; (back row) Tony "Buck" Sluger, Victor "Vic" Ujcic, Stanley "Stosh" Ujcic, Tony "Kitty" Gruden, John "Jay" Kerjic, "Frank" Belinc, "Ernie" ?, and coach John "Pop" Kosanic. (Courtesy Frances Tekavec.)

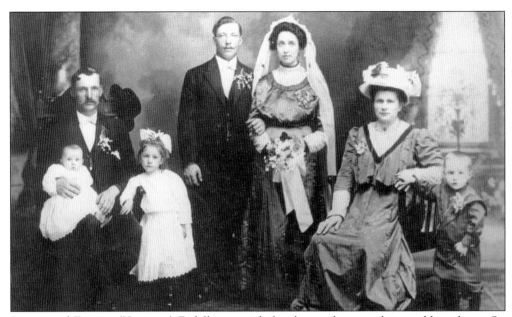

Jerome and Frances (Kocjanic) Zadell pose with family members on their wedding day at St. Veronica's Catholic Church in Davis in 1913. Both Mr. and Mrs. Zadell were born in Slovenia. They both worked in the Babcock Lumber Company camps around the Blackwater country until the company closed in the early 1920s. Mr. Zadell worked as a lumberman and teamster. Mrs. Zadell worked as a cook, at times feeding 80 men three meals a day. They remained in Davis, raised their family, and became proud U.S. citizens in their early 50s. (Courtesy Frances Tekavec.)

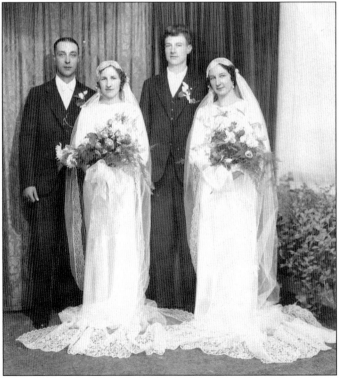

Bride Frances Zadell (daughter of Jerome and Frances Zadell) and bridegroom Frank Tekavec (on the right) were married in 1934 in a double ring ceremony with friends Anna Zalar and Andy Zalar. The American brides wore white dresses, moving away from the traditional red or black dresses typically worn by Slovenian women on their wedding days. This shift was symbolic of the challenges faced by families trying to adapt to their new homes and the wish to keep traditional values and ceremonies alive. (Courtesy Frances Tekavec.)

Six
UP IN THE VALLEY
Canaan Valley

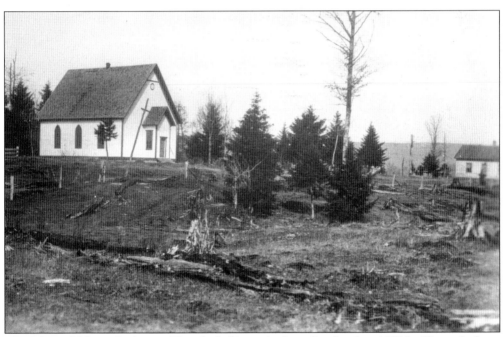

The Mount Hebron Lutheran Church (left) was built at Cortland in 1897 by Henry Jackson Cooper. Cooper built the church because, "I have made all I have from this little Valley, and I wanted to give its people what is needed for a church." An artisan from Winchester, Virginia, was commissioned by Cooper to print the Lord's Prayer in gold leaf on one of the walls of the church. Many children learned to recite this prayer by referring to the words on the wall. Henry J. Cooper came to Canaan Valley in the spring of 1882, bringing with him a wife and seven children ranging in age from 14 to 2. An eighth child, Myrtle, was born in Canaan Valley in November 1882. The Cortland School appears on the right. The Cooper children were included in the numbers of local children who were schooled here. The school closed its doors in 1933, and the church remained until 1944. (Courtesy Virginia Cooper Parsons.)

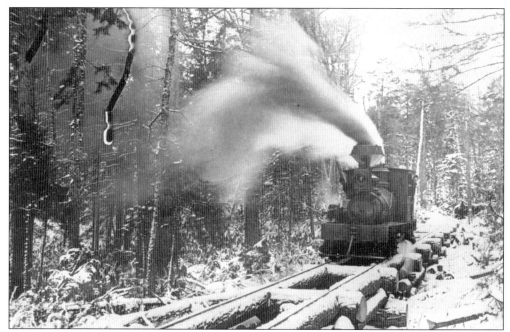

This Shay engine travels on a "stringer" railroad in Canaan Valley. Stringer lines were constructed to negotiate rough or wet terrain without the need for extensive grading. Logs were hewn on one face to hold the rails. Ties, made from large trees that had been cut and notched, held the stringers in place. Ends of the stringer were then squared to fit into the openings in the ties. The whole construction was supported and leveled by other logs. (Courtesy Virginia Cooper Parsons.)

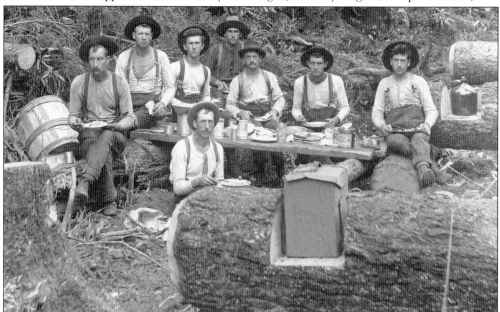

A logging crew breaks for mid-day dinner. It appears that these men have been working on constructing a stinger railroad. Notice the notches in the ties waiting for the stringer elements to be inserted. Brothers Frank Cooper (seated far left, with mustache) and Fred Cooper (center, back row, in dark shirt) worked as members of the crew. (Courtesy Virginia Cooper Parsons.)

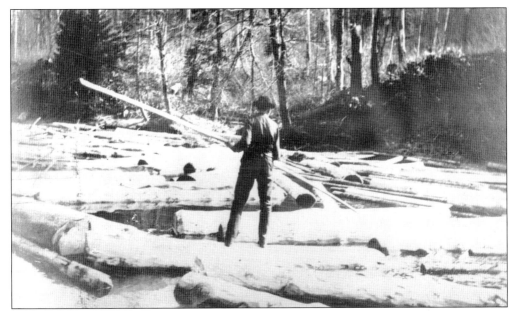

Before logging railroads were constructed, logs were brought to sawmills by floating them on rivers. The earliest log drive on the Blackwater took place in March 1886 from Canaan Valley. Included in the crew were William Cooper, Johnny McFaw, Louis Carroll, George Warner, and Charles, Truman, and James Root. A year earlier, J. L. Rumbarger had arranged for timber to be cut and skidded to the Blackwater in order for it to be floated downstream to his sawmill in Davis. (Courtesy Frances Tekavec.)

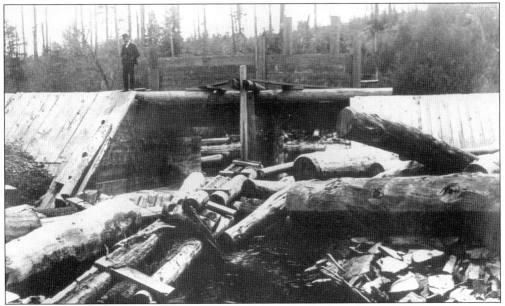

Pictured here around 1902 is Sumner Thompson, brother of Albert Thompson. Thompson stands atop a splash dam constructed on the Blackwater River in Canaan Valley. This splash dam was built to provide a controlled flow of water for driving logs to the Thompson mill in Davis. This particular structure was completed in 1889 at the cost of about $2,500 and was located about 18 miles upriver from Davis. (Courtesy Virginia Cooper Parsons.)

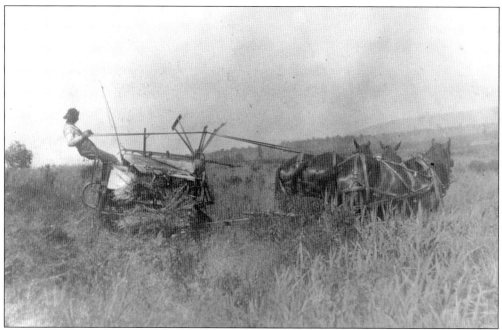

Bob Cooper drives a team of horses while harvesting oats. This scene from the early 1900s took place in Canaan Valley. Farmers in Canaan Valley often shared farming equipment and labor to bring in crops of oats, buckwheat, and hay. These seasonal events not only allowed the farmers to share in the labor but provided a social gathering for the families. (Courtesy Dorothy Thompson.)

McDonald Glades is shown in 1906 with stacks of wild grass used as feed for livestock. These fields provided areas for grazing during summer months. At summer's end, the grass was harvested for hay. In some areas of Canaan Valley, grasses such as blue joint grass and oat-grass occur naturally. Logs seen in the stream were probably being held there until they could be floated down to the Blackwater. (Courtesy Dorothy Thompson.)

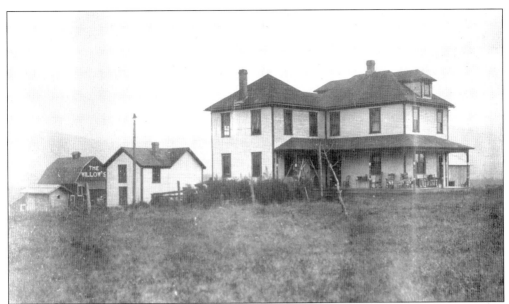

This farm home and the land surrounding were known as "The Willows." Pictured about 1920, it was located in Canaan Valley and was the home of George Thompson and his descendants. George Thompson was the nephew of Albert Thompson, owner of Blackwater Boom & Lumber. In an ironic twist of fate, the farm was located on land once owned by Robert Ward Eastham, the man who took the life of Frank E. Thompson, son of Albert Thompson (see related photo and caption, page 108). Robert Eastham escaped jail in Parsons while serving his sentence, returned to his native Virginia, and never returned to West Virginia. Eastham held the farm until 1903, when he sold it to a neighbor, old friend, and fellow Confederate veteran, Henry J. Cooper. Two years later, Cooper sold it to Albert Thompson, who passed it along in 1907 to his nephew, George Thompson. The Eastham acreage became part of a farm where George Thompson lived after he retired as general manager of the Babcock Lumber & Boom Company in 1918. (Courtesy Dorothy Thompson.)

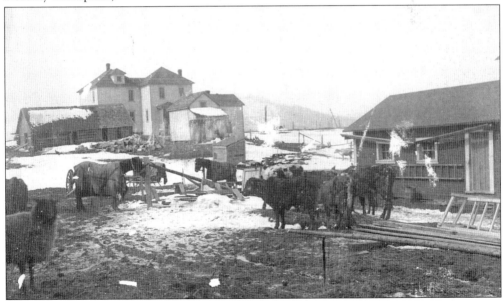

The Parsons family of Canaan Valley pitches in to pack up the cauliflower crop for shipment in the early 1950s. Crops such as cauliflower, broccoli, and Brussels sprouts were grown in Canaan Valley beginning around 1943. These crops required hours of back-breaking work and care in the field to yield a quality crop. They found their ways to markets in urban areas of Pennsylvania and Maryland. (Courtesy Virginia Cooper Parsons.)

Jacque Parsons, son of Cecil Parsons and Virginia (Cooper) Parsons, is shown here in the early 1950s in Canaan Valley with Tucker County extension agent Carl Hardin. Parsons completed a bachelor's degree at West Virginia University and a master's degree from the University of Maryland, and was a professor of horticulture in charge of the Agricultural Center in Oregon City, Oregon. Parsons continues to work as a farmer in Oregon. (Courtesy Virginia Cooper Parsons.)

Pictured are James Copeman (Monongahela Power Company) and Reardon Cuppett (Tucker County Superintendent of Schools) inspecting the cauliflower fields on the Graham farm in Canaan Valley. Long before ski slopes, state park lands, and second homes occupied the landscape of Canaan Valley, farmers produced crops and grew livestock in this challenging environment. (Courtesy Virginia Cooper Parsons.)

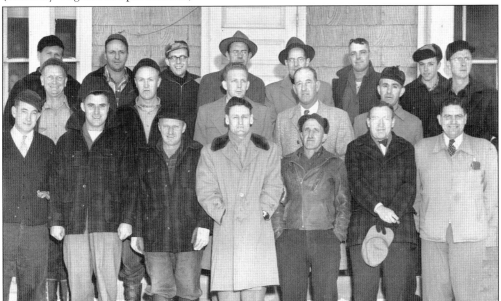

Members of a cooperative farming effort involving Canaan Valley farmers, West Virginia University Extension, and Monongahela Power are pictured here in 1947. From left to right are (front row) Roscoe Beall, Carl Hardin, Joe Cooper, Dr. M. E. Gallegly, Ben Thompson, Bob Boal, and Jim Copeman; (middle row) Red Cooper, Jack Harr, Mason Marvel, unidentified, and Hoye Smith; (back row) Pete Cosner, Raymond "Buck" Harr, unidentified, Bob Templeton, Claude Kemper, Cecil Parsons, Bill Morrow, and Dick Harr. (Courtesy Virginia Cooper Parsons.)

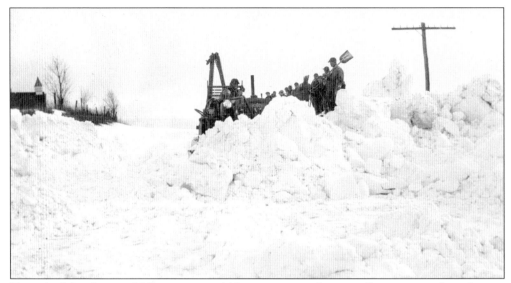

Typical of the Canaan Valley, snow and blowing snow takes its toll on man and machinery every winter. The winter of 1935–1936 may have been the worst in terms of snowfall, winds, and extremely cold temperatures. Canaan Valley weather observer Carrie Bennett recorded a total snowfall of around 200 inches from October to April. During a 43-day period of that winter, 72 men were hired to do nothing but shovel snow. (Courtesy Virginia Cooper Parsons.)

The date of this photograph is 1936. A snowbound school bus waits at the junction of Route 32 and Freeland Road to be freed from the snow. Before snowplows, roads in Canaan Valley could be blocked for days or weeks. Students from the valley usually attended high school in Davis. In the days before efficient snow removal, many students boarded in private homes or lived with relatives in the town. (Courtesy Tucker County Historical Society.)

Canaan Valley and Dolly Sods were used as staging and training areas for troops during World War II. Known to the military as the "West Virginia Maneuver Area," Dolly Sods was an artillery range used by the 13th Army Corps of the Third Army. The training went on from the summer of 1943 until July 1944. Troop numbers peaked in 1944 at 16,000. (Courtesy USDA Forest Service, Monongahela National Forest.)

As part of the army maneuvers, there were three gun emplacements: in Canaan Valley, along Forest Road 75, and along the Allegheny Front. From these positions, artillery was fired at Blackbird Knob and Cabin Mountain. Mortars, located in these and many other locations, were also used. The search and removal of unexploded ordnance from these exercises is an on-going process. (Courtesy USDA Forest Service, Monongahela National Forest.)

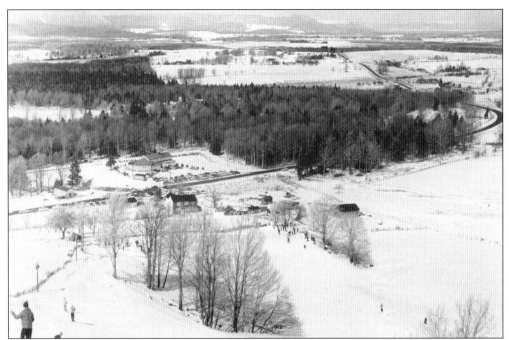

Canaan Valley's reputation for long winters with abundant amounts of snow paid off in the early 1950s. During the winter of 1949–1950, skiers from the Ski Club of Washington, D.C. (SCWDC), found in West Virginia what they were looking for. After a winter of less than normal snowfall in most of the Eastern United States, skiers were hungry for powder and also fell in love with the Canaan Valley view. (Courtesy USDA Forest Service, Monongahela National Forest.)

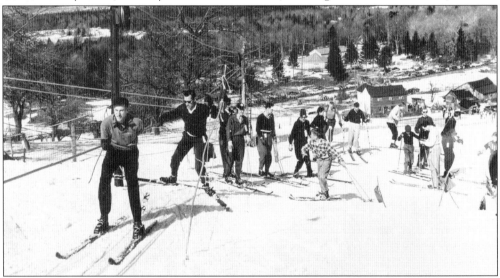

With lots of enthusiasm and elbow grease, members of SCWDC and supportive locals installed a used rope tow on Cabin Mountain that was powered by an old truck motor and chassis. Organizations like the Blackwater Civic Association and Davis Ski Club Council, along with local businessmen and citizens like Belmont Cleaver, Ed Filler, Ralph Good, Jim Meyer, William Miller, and Gerald Parks, supported the concept and development of the fledgling industry. (Courtesy David F. Strahin.)

Robert "Bob" Barton developed and managed the Weiss Knob Ski Area. Barton installed a 1,240-foot rope tow in 1955 to make ready for customers at this first commercial ski area south of the Mason-Dixon Line. In January 1956, the first official ski week at Weiss Knob Ski Area began. The Weiss Knob Ski Area was the predecessor to the present-day Canaan Valley Resort ski area. (Courtesy John Lutz.)

Before skiing came to Canaan Valley, a rope tow was something that got one out of the snow, not to the snow. Today, it is hard to believe that in 1955, this rope tow was the state-of-the-art technology that moved skiers to the top of the mountain. By the early 1970s, chair lifts arrived in the valley and provided a more sophisticated means of getting up the slope. (Courtesy John Lutz.)

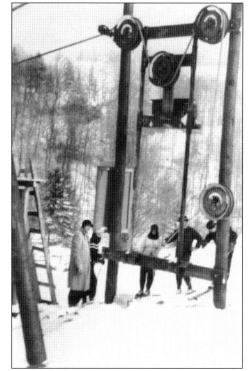

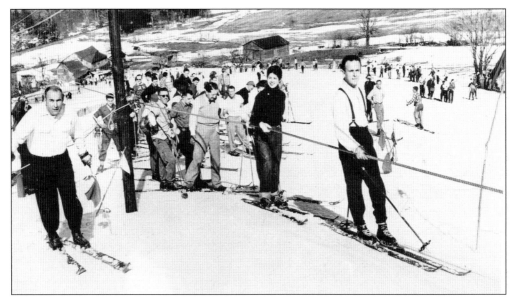

Ed Filler, at far left, was a local businessman who encouraged the growth of the ski industry on Canaan Valley's Cabin Mountain. He was the chairman of the Blackwater Civic Association's Ski Cooperation Committee and probably was one of the few local people who had "ski" in his vocabulary. Filler had received ski training while in the army.

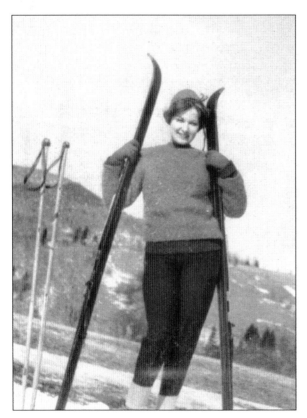

With skiing in Canaan Valley came a variety of après ski events connected with the sport. During Winter Carnival festivities, which began in 1955, associated events included a parade, torch light skiing, ice skating, and a slalom race in costume. The Snowball Dance was held at the Davis High School gym, with the crowning of a carnival queen. Sunday morning brought the blessing of the skis at St. Veronica's Catholic Church in Davis. (Courtesy John Lutz.)

Seven

WOOD HICKS AND KNOT BUMPERS
Forty Years of Logging

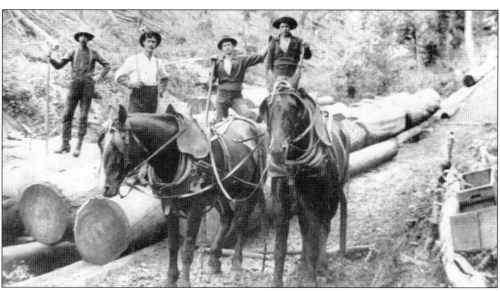

This early photograph was taken near Mackeyville in 1893. Teamsters performed one of the most dangerous and important jobs in the logging camp. These men and their teams were in high demand from early large- and small-scale lumbering operations. They usually were up before the other members of the logging crew to curry and feed their teams of draft horses before breakfast. When the day's work began, teamsters harnessed their teams and drove them up the skid road to where the men were felling logs. Methods of bringing timber to the processing site utilized animals to "skid" the logs to the mill. Even when more efficient ways for delivery of timber were developed, horses remained a dependable and integral part of the logging industry. (Courtesy USDA Forest Service, Monongahela National Forest.)

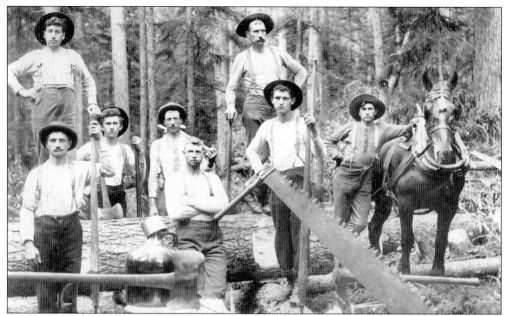

This Canaan Valley logging crew, or "wood hicks," proudly displays the specialized tools of their trade. Included in this log crew's arsenal used to fell the trees of the forest is a peavey, a double bitted axe, a cross cut saw, a pike, and a draft horse. Pictured among these men are G. Frank Cooper (standing on the log with mustache) and his brother Fred A. Cooper (leaning on the horse), both residents of Canaan Valley. (Courtesy Virginia Cooper Parsons.)

Brothers Edward and Neil Heiskell came to the Davis from Hampshire County, West Virginia, in 1887. Neil Heiskell was a skilled horse handler, and his teams assisted in clearing the town site of Davis. In this photograph, he shows off one of his teams of sturdy draft horses. Heiskell later expanded on his successful business by offering single and double rigs and riding horses for hire. (Courtesy Dorothy Thompson.)

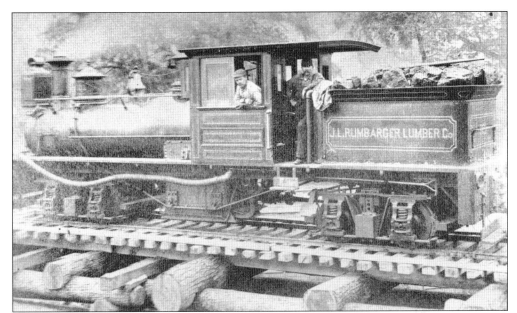

Jacob L. Rumbarger arrived in the Davis area from Indiana in 1884 after hearing of the potential for harvesting hardwoods. He hurriedly set up his company and purchased several stands of cherry timber in Canaan Valley. In 1885, Rumbarger sent crews and equipment to cut the timber. The first log drive on the Blackwater River took place in March 1886 and provided Rumbarger enough timber downstream in Davis to start cutting at his newly constructed bandsaw mill. (Courtesy David F. Strahin.)

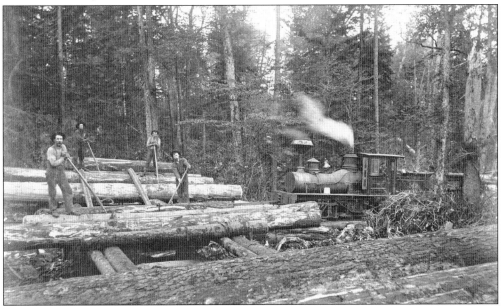

Men use a specialized tool called a peavey to roll logs to the river in Canaan Valley. Also shown in this picture is the first Shay engine used by Albert Thompson's logging operations in Canaan Valley (far right). Locomotive No. 142 was built in 1886 for Thompson's logging operations in Ridgeway, Pennsylvania. Thompson brought the 15-ton locomotive to Davis soon after he established the Blackwater Boom & Lumber Company in 1888. (Courtesy Dorothy Thompson.)

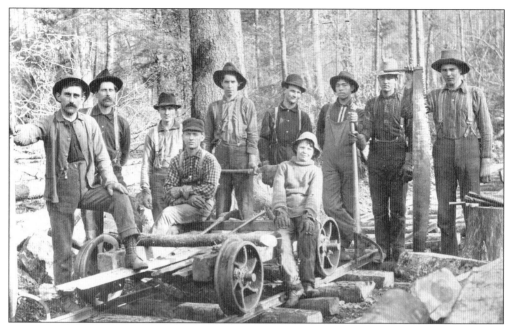

This section crew worked at William in 1903. The grading and construction of early logging railroads was accomplished largely by hand. Workers were also known as "gandy dancers." The working of young boys on such crews was not unusual. During later years, machinery supplemented hand labor. (Courtesy West Virginia and Regional History Collection, WVU Libraries.)

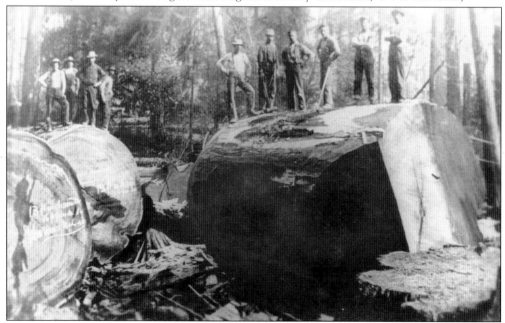

The largest known tree ever cut by lumbermen in West Virginia grew near Leadmine, Tucker County. This giant white oak was 13 feet in diameter 16 feet from the base, and 10 feet in diameter 31 feet from the base. Cut in 1913, the tree was notched on three sides with axes then sawed with a regular cross-cut saw to bring the giant down. (USDA Forest Service, Monongahela National Forest.)

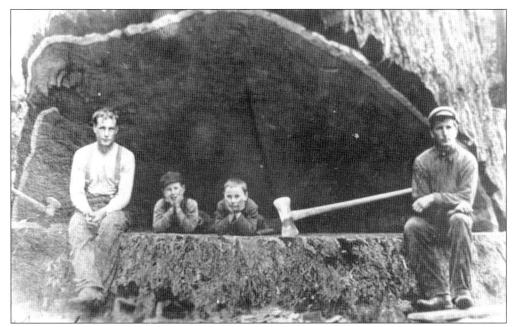

Howard and Obie Bohon, brothers from Leadmine, sit in the notch of the giant oak tree pictured on page 104 with two unidentified boys. After the tree was felled, sections had to be drilled and dynamited to reduce the pieces to a size that made it possible for transport by rail. The wood ended up at the Kendall Lumber Company sawmill in Crellin, Maryland. (USDA Forest Service, Monongahela National Forest.)

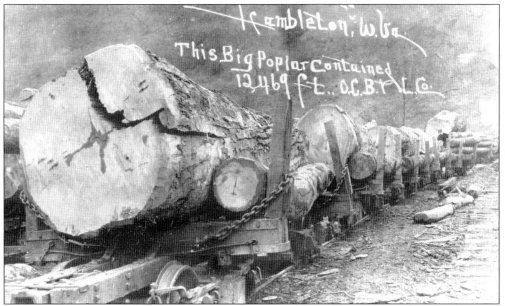

A giant yellow poplar was cut near Camp No. 3 on Green Mountain near Otter Creek in 1913. Transporting the logs to the Otter Creek Boom and Lumber Company mill for processing required an entire log train, made up of nine fully loaded cars. The tree yielded an incredible 12,469 board feet. If laid end-to-end, the boards would have stretched almost two miles. (Courtesy David F. Strahin.)

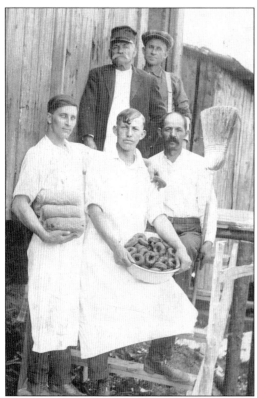

Lee Caplinger, Sonny Hauser, Poker Joe, Dewey W., and an unidentified man proudly pose with elements of the next lumber camp meal. Food, both quality and quantity, was an important recruiting tool. Loggers were willing to work hard if the camp cook was a good one. A cook usually was the highest paid man in the camp and was routinely paid more than skilled tradesmen like blacksmiths and carpenters. (Courtesy Tucker County Historical Society.)

This lumber camp table is set for supper. All the food was put on the table before the loggers were called in. Plates were laid upside down, and a tin cup was placed on top. The menu usually consisted of sliced boiled or roasted meat, mounds of boiled or fried potatoes, huge bowls of canned corn, cabbage, and stewed tomatoes, beans, plates of cookies, doughnuts, thick slices of bread, cakes, and pies cut into quarters, with pots of strong coffee and milk. (Courtesy Jane Barb.)

Sheep are shown being held in stock pen near the rail yard in Davis. The Babcock Lumber Company began to develop some of their property holdings as range land and for agricultural use on their immense land holdings surrounding Davis. In 1912, hay, oats, and potatoes were grown on property near Beaver Creek. Cattle grazed on portions of a vast 12,000-acre tract. All these efforts were to produce "fuel" to feed their ever hungry logging crews. (Courtesy Dorothy Thompson.)

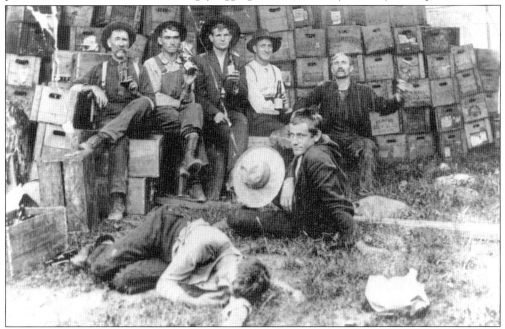

Wood hicks lift a few cold ones in the backyard of Bradshaw's saloon at Laneville in 1905. Life in the woods was a hard one for logging crews. Work could go on for 10 hours a day, 6 days a week, depending on the time of year, with only a short rest for a mid-day meal. An occasional visit to town usually resulted in overindulgence in every vice one could think of. With their return to camp, the men usually found their bankrolls a little lighter and the work just as grueling as before. (Courtesy USDA Forest Service, Monongahela National Forest.)

Frank Elmer Thompson (1861–1897) was the only son of Albert Thompson, owner of the Blackwater Boom & Lumber Company in Davis, making him the heir-apparent to the Thompson business. Thompson's promising future was cut short when he was shot to death by Robert W. Eastham in March 1897. Eastham was convicted by a jury of involuntary manslaughter but served only one year of a two-year sentence. He escaped jail in 1898, returned to his native Virginia, and died in 1924 at the age of 82. He never returned to West Virginia. (Courtesy Dorothy Thompson.)

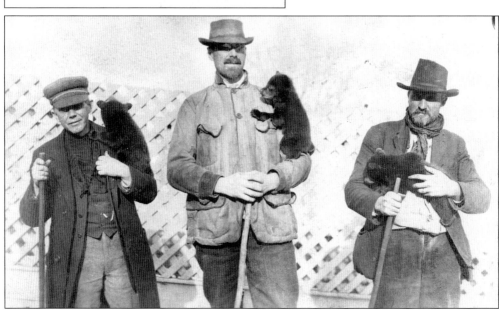

Pictured here are George Thompson, Edward V. "Squire" Babcock, and Fred Viering with three bear cubs captured in Blackwater Canyon in 1911. Thompson was a nephew of Albert Thompson, owner of the Blackwater Boom & Lumber Company, and held several positions in that company. Thompson then worked for the Babcock Lumber & Boom Company until his retirement as general manager in 1918. (Courtesy Frances Tekavec.)

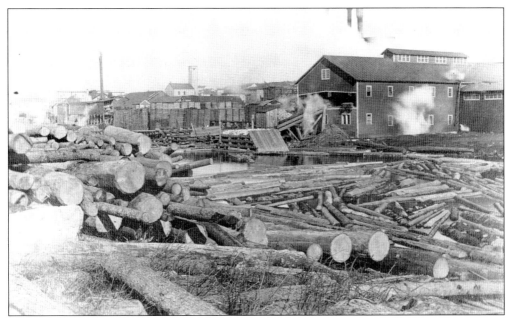

Blackwater Boom & Lumber Company operated along the Blackwater River under the leadership of Albert Thompson from 1894 until 1905. During an 11-year period, the operation made improvements to the mill in Davis (pictured here). Thompson Lumber Company briefly took over the operations in 1905 but two years later sold to the Babcock Lumber & Boom Company. That company operated in the area until 1924. (Courtesy Western Maryland Railway Historical Society.)

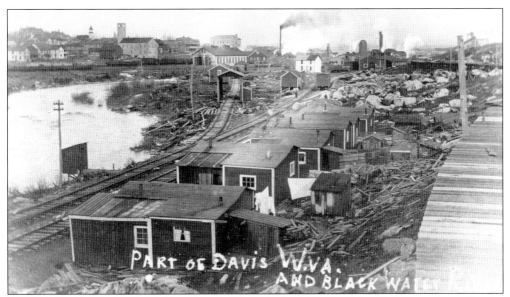

This panorama of Davis in 1910 was taken from the south side of the Blackwater River. Smoke stacks of the Babcock Lumber & Boom Company can be seen in the background. Small dwellings appear between the railroad tracks and a boardwalk (right). "Shanties" were used as housing by groups of individuals or families who worked in the lumber camps. Because of their size and temporary nature, the structures could be lifted onto railroad cars and transported to the next logging job. (Courtesy Western Maryland Railway Historical Society.)

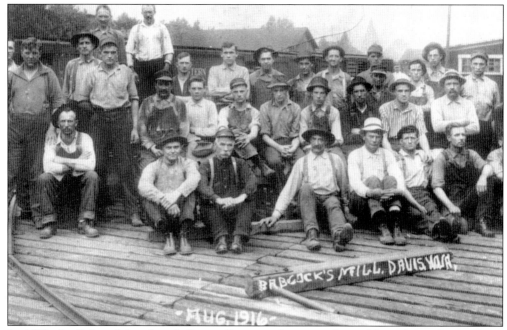

In 1907, the Babcock Lumber & Boom Company began to depend heavily on foreign-born labor. These workers were mostly Austrian (which at the time included Slovenians, Hungarians, and Tyrolese) and Italians. Previously, most skilled lumbermen came from places where timber resources had been cut like Pennsylvania, New York, Michigan, Virginia, and parts of New England. Comparatively speaking, few workers were native West Virginians.

Born in 1863 in Germany, Frederick W. Viering moved to Davis in 1907 to work for the Babcock Lumber & Boom Company. Viering was a civil engineer and held several patents for logging machinery. One of the biggest challenges to Viering and the Babcock logging operations was logging the steep slopes of the Blackwater Canyon. When Viering died tragically in 1924, his death marked the end of logging operations by Babcock in the area. (Courtesy Dorothy Thompson.)

Logging the Blackwater Canyon presented unique engineering challenges because of extreme terrain. After conventional methods of logging failed to provide access to the timber on the south side of the Blackwater Canyon, engineers and crews from the Babcock began to use Lidgerwood aerial skidders. Visitors from as far away as Michigan, Japan, and Russia made the trip to Davis to witness the innovation in logging technology utilized in the Blackwater operations. (Courtesy Dorothy Thompson.)

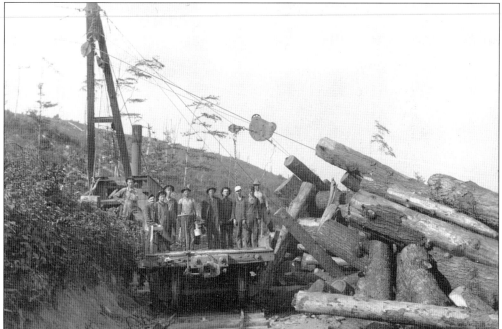

Steam skidders enabled crews to log out a circle with a radius of one-half to three-quarters of a mile. Logs were skidded by cable to a landing and then loaded on a railroad log car. Skidder crews usually consisted of four to five men who worked in a coordinated effort. Crews prepared logs to be hooked to the cable. When log loads were ready, a whistle was sounded and they commenced to pull until signaled to stop. (Courtesy Dorothy Thompson.)

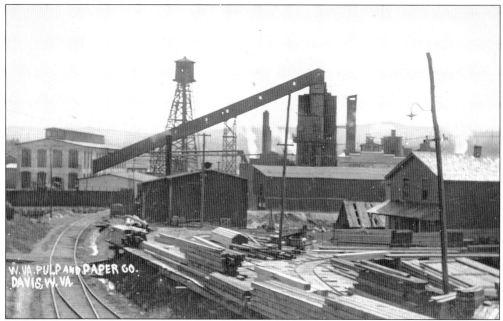

West Virginia Pulp and Paper Company in Davis started operations in 1895. Huge tracts of timber near Davis provided the raw material needed for production of pulp. The destination of much of this pulpwood was a plant in the neighborhood of Piedmont, West Virginia, and later Luke, Maryland. At the time, some of the finest papers in the country were made from the pulpwood that came from these plants. (Courtesy Dorothy Thompson.)

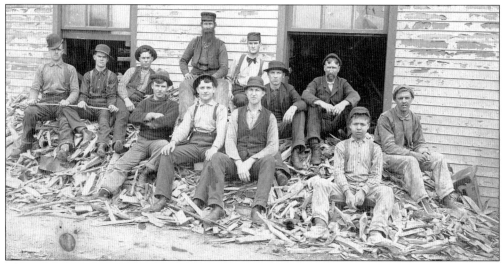

The West Virginia Pulp and Paper mill operated in Davis from 1892 until 1919. Employees of the pulp and paper mill in Davis went on strike in February 1919 in sympathy for fellow workers in Luke, Maryland, and Tyrone, Pennsylvania. In all, at least 2,000 workers were affected. Among the demands were an eight-hour day and a 33¢-per-hour minimum wage for women workers. The response by West Virginia Pulp and Paper was to close the mill and never reopen. (Courtesy Tucker County Historical Society.)

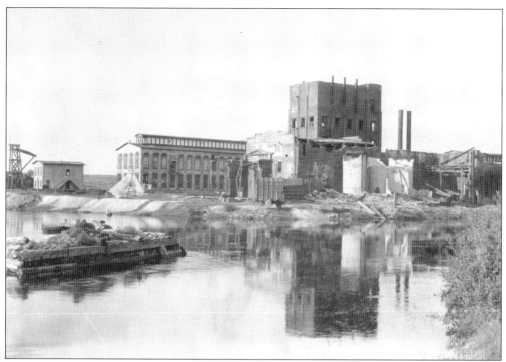

Remnants of the extensive pulp mill complex in Davis slowly deteriorated over decades. This picture shows the once-active mill site in 1933. The plant had been idle for just over a decade. Rubble remained for nearly 50 years, until most of the evidence of the burgeoning industry disappeared. (Courtesy USDA Forest Service, Monongahela National Forest.)

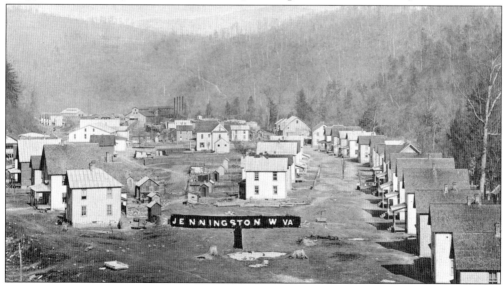

Situated on a narrow, flat river plain hemmed in by mountains and the Dry Fork River, Jenningston was one of the towns that fell into obscurity after the boom times of the early 20th century. This photo of Jenningston was taken around 1910 looking toward the Laurel River Lumber Company mill. The town was founded in 1905 by the brothers B. Worth, Courtney H., and William Jennings, who came from Pennsylvania to establish a sawmill business. (Courtesy Dorothy Thompson.)

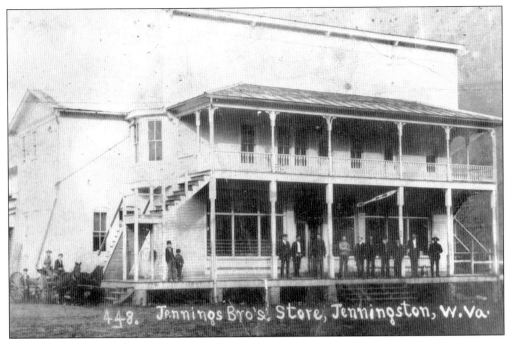

The Jennings brothers laid out the town along three parallel streets (Front, Center, and River), which ran the full length of town. In 1910, there were 76 dwellings, 13 commercial buildings, and 16 mill buildings, for a total of 105 buildings. There was a public school and church. Nearby was the train station, a clothing store, restaurant, general store, barber shop, and pool room. (Courtesy P. K. Salovaara.)

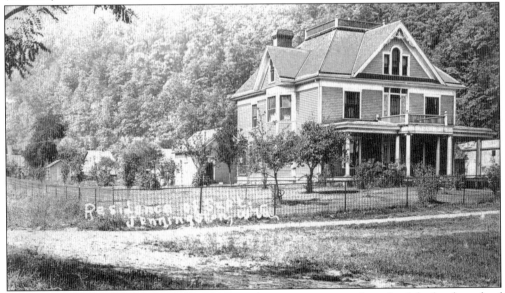

Laurel River Lumber Company and its associated structures occupied much of the land south of the town of Jenningston. In 1910, the population was 300. By 1920, the population had doubled, as had the number of buildings. Unfortunately, in 1921, the sawmill business pulled out of Jenningston, beginning its decline. One of the few remaining buildings is the impressive home of the Jennings family, built in the early 1900s. (Courtesy P. K. Salovaara.)

Eight

TO PROTECT AND RESTORE
Forest Recovery

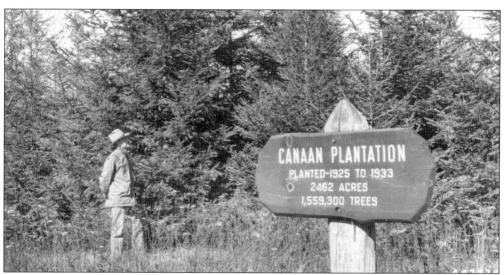

Canaan Plantation is contained within the Monongahela National Forest (MNF). It was the site of a reforestation project that planted 1,559,300 trees on 2,462 acres from 1925 to 1933. In 1911, the Weeks Act permitted the federal government to purchase acreage through the Forest Service for watershed protection and natural resource management. Soon after the passage of the Weeks Act, Thomas J. Arnold signed a proposal to sell 7,200 acres in Tucker County to the Forest Service. In 1915, this became the first government purchase of any property within what is now the MNF. Watershed protection in the form of forest growth was one of the reasons for MNF's formation. Before the forest was cut down in the late 1800s and early 1900s, this area was known to have some of the largest trees and densest forests found anywhere in North America. (Courtesy USDA Forest Service, Monongahela Forest Service.)

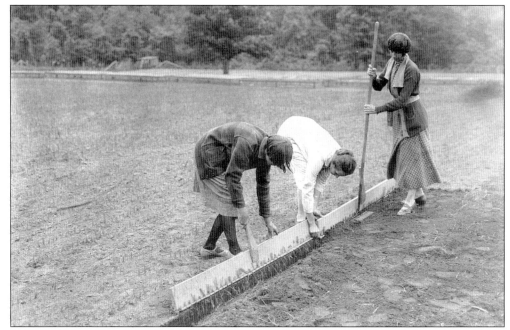

In 1919, the Forest Service established its first experimental tree nursery at Gladwin, along the Dry Fork River. Known as the Monongahela-Gladwin Nursery, it had 720 square feet of seed beds, which later expanded to almost an acre. Norway spruce and European larch were planted. The women in this picture are seen planting seedlings. Larch proved too difficult to grow, while spruce did exceptionally well. (Courtesy USDA Forest Service, Monongahela Forest Service.)

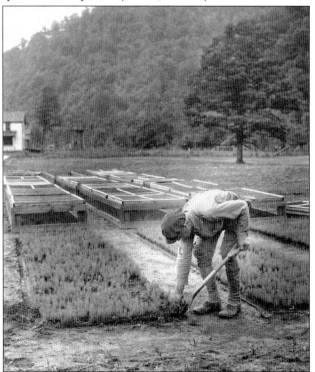

The Forest Service began to replant the forest from seedlings in 1919. Although the Gladwin facility progressed slowly, funding was poor and it was denied a full-time nurseryman. The Gladwin Nursery closed in 1927 because of its inaccessible location and inability to provide the Monongahela National Forest with seedlings for the 40,000 acres designated for replanting. (Courtesy USDA Forest Service, Monongahela Forest Service.)

This fire tower reportedly was the first to stand in the Cheat District of the Monongahela National Forest. Originally built by the State of West Virginia in 1922, it was located on Backbone Mountain. MNF acquired it in 1935, when this photograph was taken, and used the structure until 1963. Olson Tower stands in its place today and was named in memory of Ernst Olson, a 28-year Forest Service employee, who died in an automobile accident in 1961. (Courtesy USDA Forest Service, Monongahela Forest Service.)

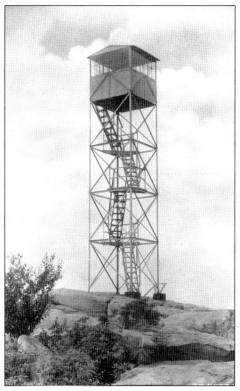

The first lookout structure in the MNF built by the Forest Service stood at Canaan Mountain. One of the priorities of the MNF was fire prevention. In the scrub lands that comprised the forest in the early years, fire was the number one problem. To help prevent the spread of forest fires, a series of fire towers were constructed including this one, the Canaan Mountain Lookout. (Courtesy USDA Forest Service, Monongahela Forest Service.)

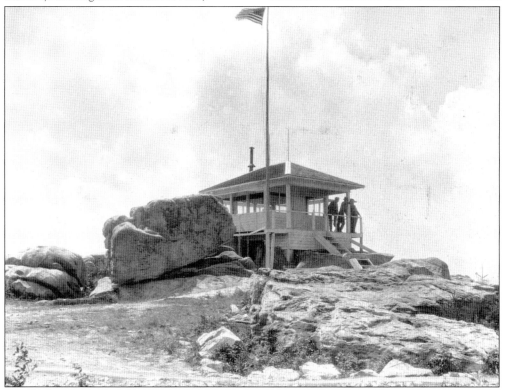

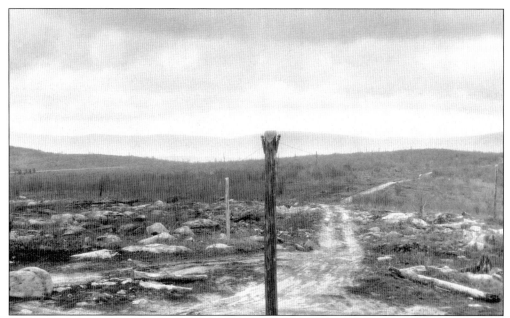

This picture was taken in 1933 from the location of the Canaan Fire Tower. Fire towers were supplemented with telephone lines (seen in this picture), and by 1931, there were 250 miles of wire connecting various lookout tower and fire stations in the Monongahela National Forest. Perched atop "Elephant Rocks," the remnants of the concrete foundation can still be seen off Forest Road 13. (Courtesy USDA Forest Service, Monongahela Forest Service.)

Just over 20 years later (1954), the same camera angle shows the re-vegetation of Canaan Mountain. In the previous picture, newly planted Norway spruce seedlings are just 15 inches high and cannot be seen. In 20 years, the trees have obscured the view. This area was part of a reforestation project, which planted 1,559,300 trees on 2,462 acres of Canaan Mountain from 1925 to 1933. (Courtesy USDA Forest Service, Monongahela Forest Service.)

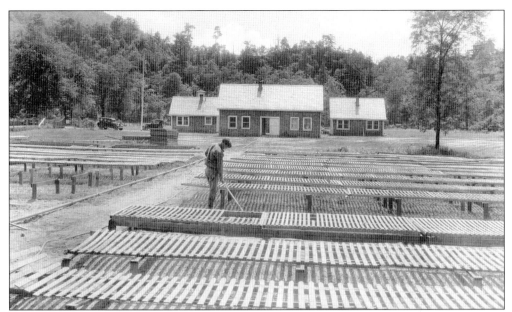

In 1928, the purchase of 28 acres was approved for a new nursery at Parsons. Nearly 450 acres of trees had been planted in the MNF from 1921 to 1928. By 1931, the number of reforested acres had risen to 1,810, thanks to the success of Parsons Nursery. In 1936–1937, the facility was growing 7.5 million trees. Parsons Nursery became the largest tree nursery for reforestation in the Eastern United States and employed 116 local men and women. (Courtesy USDA Forest Service, Monongahela Forest Service.)

During its first year of operation in 1928, the Parsons Nursery bottom site contained a nursery office, wash house, workshop/storehouse, pump house, garage, and two equipment depots. By 1934, the nursery had a nurseryman's residence and garage, cone shed, and seed extractor shed. Finally, in 1937–1938, the site received its last administrative complex, the Cheat Ranger District office, residence, and garage. (Courtesy USDA Forest Service, Monongahela Forest Service.)

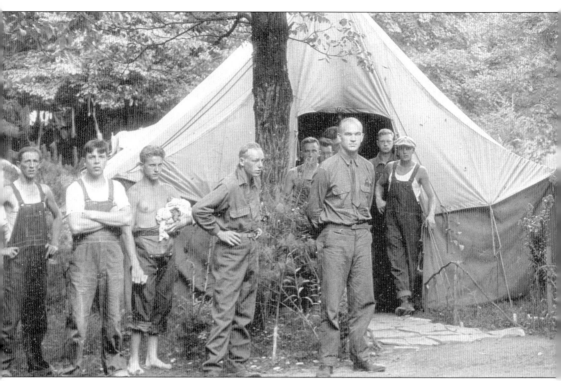

Pres. Franklin D. Roosevelt created the Civilian Conservation Corps (CCC) in 1933 as a response to the millions of unemployed young American men and the destruction of millions of acres of the country's natural resources. The CCC enrollees, ages 18 to 25, were enlisted to work on construction and maintenance projects in forest, parks, and range lands. Before the CCC was

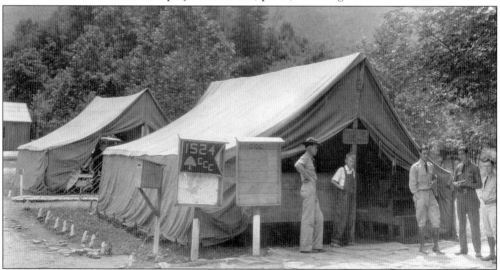

Camp Leadmine was one of the 66 authorized Civilian Conservation Corps camps in the state of West Virginia. The camp received the designation of CCC Company 1524 and operated from June 1933 until May 1934. There were 221 enrollees at the camp, 26 from West Virginia and 195 from Ohio. Pictured here in September 1933 are the officers of the camp in front of the Orderly Tent. (Courtesy USDA Forest Service, Monongahela Forest Service.)

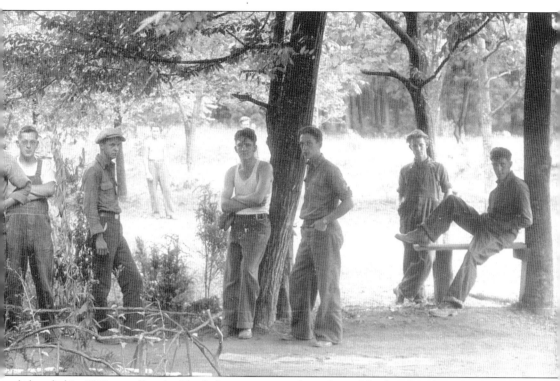

disbanded in 1942, enrollees had built fires towers, truck roads, and fire breaks; planted millions of trees; reclaimed thousands of acres from erosion; built countless federal and state parks and campgrounds; and improved fish and wildlife habitats. (Courtesy USDA Forest Service, Monongahela Forest Service.)

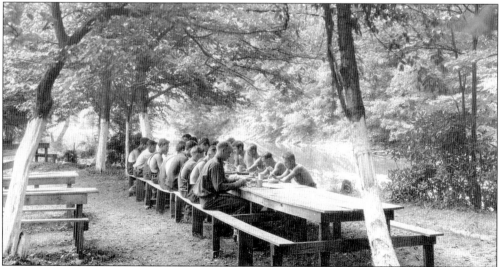

Camp staff usually consisted of a company commander, a junior officer, an educational advisor, a camp doctor, and a project superintendent. The men typically stayed in tents shared by four to six men until more permanent accommodations were built. Typical layout of the camps included a kitchen/mess hall, recreational building, educational building, infirmary, enrollee barracks, and officer and personnel quarters. (Courtesy USDA Forest Service, Monongahela Forest Service.)

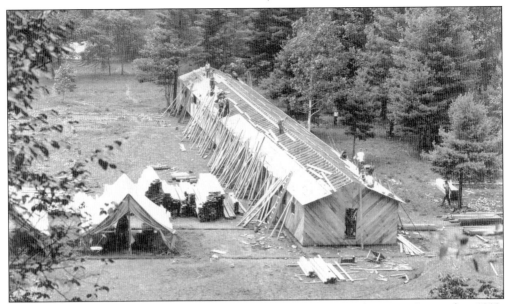

This photo shows the construction of the CCC barracks at Leadmine in September 1933. While CCC camps were being constructed in 1933, the earliest enrollees stayed at nearby tent camps. Permanent buildings were later constructed by the enrollees. The camp was not approved for continued occupation and closed in May 1934. Enrollees with Company 1524 were transferred to Camp Hardy in Lost River State Park. (Courtesy USDA Forest Service, Monongahela Forest Service.)

Camp Leadmine was abandoned in 1934 and became the location for Camp Horseshoe. The YMCA almost immediately took over sponsorship and maintenance of Camp Horseshoe through a special use permit with the Monongahela National Forest. Long-term use and care by the YMCA has resulted in the preservation of 19 buildings and structures constructed by the CCC. Shown here is the camp kitchen and dining hall in 1946. (Courtesy USDA Forest Service, Monongahela Forest Service.)

Nine
BOUNTIFUL GIFTS
Natural Resources

This beauty lounges at the base of Blackwater Falls near Davis. This photo, taken in 1935, provides a glimpse into the attraction of this dramatic backdrop. At this point on the Blackwater, the river drops a dramatic 65 feet over the falls. Blackwater Falls may be the most recognized landmark in Tucker County, if not all of West Virginia. It has long been a favorite of locals and visitors alike. West Virginia Power and Transmission owned the land in 1930 and, in 1935, gave the State Park Commission a 10-year, rent-free lease of approximately 450 acres, which became Blackwater Falls Park. Blackwater Falls State Park was established in 1937. The power company deeded nearly 1,000 acres to add to the state park in 1953. Within five years, a lodge was completed and ready for guests at the rim of Blackwater Canyon. (Courtesy USDA Forest Service, Monongahela Forest Service.)

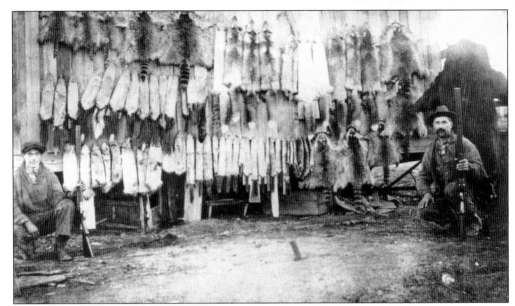

Here are Albert Knotts (right) and his son Herman (left) with evidence of the season's catch. Some people trapped and hunted as a profession or as a way to supplement their income and extend their supplies of meat. Pelts collected from the hunt hang in the background of this picture. Most likely included were squirrel, mink, raccoon, fox, and bear. (Courtesy David F. Strahin.)

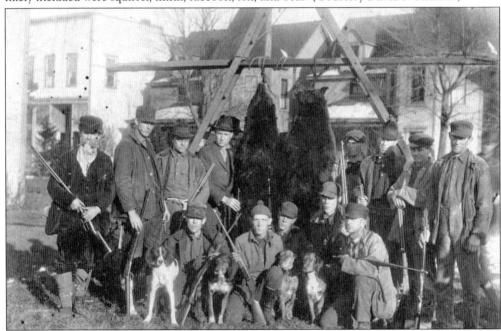

Pictured here are hunters and dogs at the end of a bear hunt. Early settlers took food, clothing, and warmth from the black bear's meat and hide. In areas where cattle and sheep were introduced, confrontations between man and bear were inevitable. Many counties started to pay bounties on bear, and campaigns to exterminate the bear continued. The plight of the bear started to change when citizens of West Virginia voted the black bear the state mammal in 1955. (Courtesy Tucker County Historical Society.)

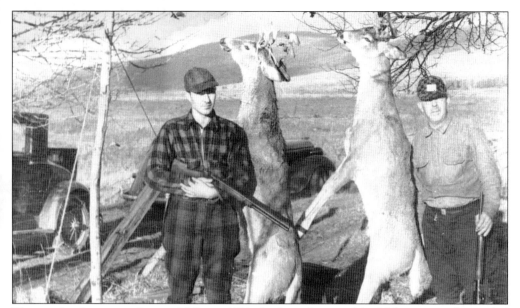

This is a deer harvest in Canaan Valley in 1920s. In the early part of the 20th century, white-tailed deer numbers suffered a decline in response to over-hunting and deforestation. Passage of laws to protect deer were enacted in 1909 but were ineffective until 1921, when regular game wardens were hired. In 1933, West Virginia embarked on a deer restocking program that continued until 1957. Numbers of deer increased again with protection and controlled hunting seasons. (Courtesy Frances Tekavec.)

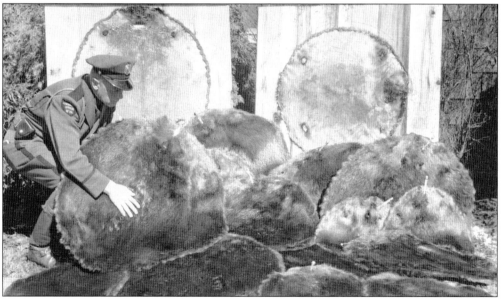

Beaver pelts from trapping are shown stretched round on a form and marked with a metallic seal by a West Virginia Conservation Commission officer in 1948. Beaver had disappeared from West Virginia by 1928. In a program led by the West Virginia Conservation Commission, beaver were re-introduced in Tucker County from 1933 to 1940. The sealing requirement allowed officers to track and enforce the harvest of beaver. (Courtesy USDA Forest Service, Monongahela Forest Service.)

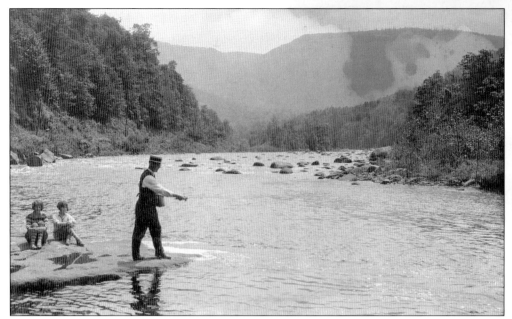

A fisherman casts his line in the Dry Fork River sometime in the 1920s. Most likely, this group arrived by train from Hendricks. Hemmed in by steep, green mountain slopes, this railroad grade was built within several feet of the Dry Fork. Today, the narrow Dry Fork Road still allows access for swimmers, boaters, and fisherman. (Courtesy USDA Forest Service, Monongahela Forest Service.)

This man prepares to dig a clump of ramps emerging from snow bank. Ramps are conspicuous in the dull spring cover of the forest floor because of their bright green, erect leaves. Also known as wild leeks, ramps earn their reputation as a spring tonic because of high levels of vitamins A and C. The distinctive pungent aroma of the plant makes it loved or hated, depending on one's taste. (Courtesy USDA Forest Service, Monongahela Forest Service.)

From Feaster Wolford's *Where the Huckleberries Grow*:

I see through the haze of late fall days Allegheny's high plateau
And my memory fills as I view these hills where the huckleberries grow.
On this tableland with a lavish hand Mother Nature vastly spread,
On the marshy ground near boulders round this vast huckleberry bed,
On the Dolly Sods where it's close to God and the huckleberries grow.
(Courtesy USDA Forest Service, Monongahela Forest Service.)

On the plains of Dolly Sods, an annual event occurs in late summer. In the past, entire families would load wagons with containers, sometimes made of bark, and go to the Huckleberry Plains on Dolly Sods for a couple of days. The combination of climate, open canopy, acidic soils, and environmental history creates conditions perfect for blueberries (known locally as huckleberries) and making memories. (Courtesy USDA Forest Service, Monongahela Forest Service.)

BIBLIOGRAPHY

Allman, Ruth Cooper. *Canaan Valley and the Black Bear*. Parsons, WV: McClain Printing Company, 1976.

Archibald, Robert R. *A Place to Remember: Using History to Build Community*. Walnut Creek, CA: Altamira Press, 1999.

Clarke, Alan. *West Virginia Central & Pittsburg Railway: A Western Maryland Predecessor*. Lynchburg, VA: TLC Publishing, Inc., 2003.

Clarkson, Roy B. *Tumult on the Mountains: Lumbering in West Virginia, 1770-1920*. Parsons, WV: McClain Printing Company, 1964.

Fansler, Homer Floyd. *History of Tucker County, West Virginia*. Parsons, WV: McClain Printing Company, 1962.

Griffin, Sam. *West Virginia Central & Pittsburg Railway Company*. Parsons, WV: McClain Printing Company, 1981.

Guthrie, Keith. "Blackwater Canyon." *The Log Train. Journal of the Mountain State Railroad and Logging Historical Association*. Vol. 10, No. 3. (Fall 1993) pp 6–12.

———. "Logging in Canaan." *The Log Train. Journal of the Mountain State Railroad and Logging Historical Association*. Vol. 14, No. 3. (Summer 1998) pp 4–20.

Harr, Milton. *The CCC Camps in West Virginia: A Record of the Civilian Conservation Corps in the Mountain State, 1933-1942*. Charleston, WV: Self-published, 1992.

Hebb, Herman. *A Time to Remember: 'Peers t' me*. Parsons, WV: McClain Printing Company, 1995.

Long, Cleta M. *History of Tucker County*. Parsons, WV: McClain Printing Company, 1996.

Mott, Pearle G. *History of Davis and Canaan Valley*. Parsons, WV: McClain Printing Company, 1972.

Nutter, Trevey Thomas. *West Virginia: History, Progress and Development, 1906*. Parsons, WV: McClain Printing Company, 1968.

Smith, Mariwyn. *. . . And Live Forever*. Parsons, WV: McClain Printing Company, 1974.

Stephenson, Steven L., ed. *Upland Forests of West Virginia*. Parsons, WV: McClain Printing Company, 1993.

Thompson, George B. *A History of the Lumber Business at Davis, West Virginia, 1885-1924*. Parsons, WV: McClain Printing Company, 1974.

Werner, Harry R. *Big Doc and Little Doc*. Parsons, WV: McClain Printing Company, 1979.

Wolford, Feaster. *Mountain Memories*. Parsons, WV: McClain Printing Company, 1975.